CONTENTS

SPONSOR'S FOREWORD

Beck's Bier is delighted to join forces with Tate Gallery Liverpool in presenting this major survey of contemporary art from Köln. At a time when the inventiveness and unique vision of both the new generation and the established modern masters of the German art scene have been making such waves internationally, it is an apt moment to present this invigorating and challenging work to a wider British public.

It seems a particularly appropriate association for Beck's Bier which is still brewed only in Bremen, Germany, and is the world's largest exporter of German bier. In Britain, Beck's Bier and the contemporary arts have become synonymous through a long term commitment to sponsoring the new and innovative – a programme which began five years ago. Beck's support has become crucial to many younger artists who would otherwise be unable to bring their projects to fruition.

This is the first occasion that we have been associated with a major exhibition at the Tate Gallery and we congratulate them in bringing together this multi-media exhibition from Köln. We hope that many people will take the opportunity to visit the show from all over Britain.

Alastair Mowat
Marketing Director, Scottish & Newcastle Breweries Plc

LENDERS

Galerie Gisela Capitain, Köln
Galerie Ascan Crone, Hamburg
Walter Dahn
Galerie Erika and Otto Friedrich, Bern
Galerie Grässlin-Ehrhardt, Frankfurt
Tanja Grunert, Köln
Galerie Max Hetzler, Köln
Kölnisches Stadtmuseum, Köln
Museum Ludwig, Köln
Galerie Janine Mautsch, Köln
Helen van der Mey
Anthony d'Offay, London
Private Collection, Köln
Private Collection, München
Karsten Schubert Ltd, London
Dr Reiner Speck Collection, Köln
Rosemarie Trockel

ART FROM KÖLN

ART FROM KÖLN
is sponsored by Beck's Bier
and supported by the City of Cologne

FINANCIAL SUPPORT FOR
THE CAPITAL COSTS OF
TATE GALLERY LIVERPOOL

The Trustees and Director are indebted to
the Merseyside Development Corporation
for their major contribution, and to the
following for their generous financial
support:

Founding Benefactor
The Wolfson Foundation

Founding Patrons
The John S Cohen Foundation
The Esmee Fairbairn Charitable Trust
Granada Television & Granada Foundation
The Henry Moore Foundation
The Moores Family Charitable Foundation
The New Moorgate Trust Fund
Ocean Transport and Trading Plc
(P H Holt Charitable Trust)
Plessey Major Systems, Liverpool
The Sainsbury Family Charitable Trust
The Bernard Sunley Charitable Foundation

Other Major Supporters
Arrowcroft Group Ltd
Barclays Bank Plc
The Baring Foundation
British Gas Plc
Deloitte Haskins & Sells
Higsons Brewery Plc
The John Lewis Partnership
The Liverpool Daily Post & Echo
The Manor Charitable Trust
The Pilgrim Trust
Pilkington Plc
The Eleanor Rathbone Charitable Trust
Royal Insurance UK & Royal Insurance Plc
Trustee Savings Bank Foundation
United Biscuits UK Ltd
Whitbread & Co Plc

Contributions have also been received from
The Beausire Trust
Blankstone Sington and Company
Charterhouse Tilney
Commercial Union Assurance Company
GMB
The Goldsmiths' Company
The Grocers' Company
Mrs Sue Hammerson
ICI
The Idlewild Trust
J P Jacobs
Kodak Ltd
The Members of Lloyds and
Lloyds Brokers
Sir Jack and Lady Lyons
Mason Owen and Partners
The Mercers' Company
Provincial Insurance
The Rogot Trust
J Rothschild Charitable Trust
Royal Bank of Scotland Plc
RTZ Chemicals Ltd
Schroder Charity Trust
John Swire and Sons Ltd
The Twenty Seven Foundation
Vernons Organisation Ltd
An Anonymous Donor

SPONSORS OF
TATE GALLERY LIVERPOOL

The Trustees and Director of the
Tate Gallery are indebted to the following
for their generous support:

Abbey Well Natural Mineral Water
Abbeville Press
Andrews Industrial Equipment
Ashton-Tate UK Ltd
Australian Bicentennial Authority
Beck's Bier
The Boston Consulting Group
Ivor Braka Ltd
British Rail
British Telecom
Bymail
Mr and Mrs Henry Cotton
DDB Needham Worldwide Ltd
Fraser Williams Group Ltd
Goethe Institute, Manchester
Granada Business Services
Greenall Whitley Plc
The Henry Moore Foundation
The Henry Moore Sculpture Trust
IBM United Kingdom Trust
ICI Chemicals and Polymers Ltd
Initial Cleaning Services
The Laura Ashley Foundation
Merseyside Task Force
MoMart
Montblanc
P & P Micro Distributors Ltd
Parkman Consulting Engineers
Patrons of New Art, Friends of the
Tate Gallery
Pentagram Design Ltd
Phaidon Press
J Ritblat Esq
Save and Prosper
Tate Gallery Foundation
Tate Gallery Publications
Tate Gallery Restaurant
Thames and Hudson Ltd
Unilever Plc
Volkswagen
Winsor and Newton
Yale University Press

Cover
CHARGESHEIMER
View of the Cathedral 1957

PREFACE

Cologne has become established over the last twenty years as one of the most important centres for contemporary art. The foundations for this success lie in history and geography, in the cultural exchange natural to a Roman town placed at the crossroads of Europe on the Rhine frontier. When the city state structure of Germany was reinstated in the form of the Federal Republic, private galleries and collections gravitated once again to Cologne, and in the late 1960's Europe's first art fair became a feature of the city's life. However, it has been Cologne's ability to attract individual artists of stature to live and work in the city which is fundamental to its importance. Its liveliness depends on the exchange of ideas between artists of very different characters drawn from all over Germany and beyond, a more sure lasting impetus for success than a dominant school or style. It is to a selection of these artists that the present exhibition pays tribute.

Beck's Bier have made this exhibition possible through their generous sponsorship. We would also like to thank the City of Cologne Cultural Department for supporting the exhibition, Baroness von Oppenheim and Hans von Portatius for their help and advice and Hasenkamp for transporting the works. Above all, we must thank the galleries and lenders who have been prepared to make loans available and the artists who have given their time and energy to participating in the exhibition.

Nicholas Serota
Director
Tate Gallery

Richard Francis
Curator
Tate Gallery Liverpool

ACKNOWLEDGMENTS

The following have helped in the preparation of the exhibition and this publication.

Thomas Borgmann
Carmel Brown
Daniel Buchholz
Olé Fischer
Dr Ehrhard Garnatz
Dr Winfried Gellner
Dr Siegfried Gohr
Bärbel Grässlin
Anneliese Greulich
Tanja Grunert
Reinhard Henning
Georg Herold
Dr Wulf Herzogonrath
Max Hetzler
Prof Klaus Honnef
Piet de Jong
Jurgen Klauke
Kaspar König
I C Kraemer
Ulrich Krempel
Lorcan O'Neil
Dr Peter Nestler
Paul Maenz
Matthew Mark
Janine Mautsch
Helen van der Mey
Anthony d'Offay
Baroness Oppenheimer
Rolf Ricke
Andreas Schulze
Bettina Schwerdtfeder
Dr Werner Shäfke
Monika Sprüth
Rolf Walz
Stephan von Weise
Dr Evelyn Weiss
Dietmar Werle
Michael Werner

Tate Gallery Liverpool acknowledges with thanks the receipt of permission from the authors and publishers to reprint the articles appearing in this catalogue.

Why Cologne?
Lucie Beyer and Karen Marta
Art in America December 1988

August Sander
August Sander
Michael Euler-Schmidt
Translated by Stewart Spencer

Chargesheimer
Chargesheimer's Photographic Work
Dr Rheinhold Misselbeck
Translated by Stewart Spencer
Edited version of text in *Chargesheimer Photographien 1949-1970,* published in 1983, Kiepenheuer and Witsch, Köln

Gerhard Richter
Gerhard Richter
Jill Lloyd
Catalogue, Anthony d'Offay Gallery 1988
Text edited

Sigmar Polke
The Art of Sigmar Polke
At the Tomb of the Unknown Picture
Donald Kuspit
Artscribe International March/April 1988
Text edited

Ulrike Rosenbach
Ulrike Rosenbach
Johannes Meinhardt
Translated by Stewart Spencer
Brennpunkt Düsseldorf 1962-1987
Exhibition 24 May-6 September 1987
Kunstmuseum Düsseldorf

Christa Näher
Christa Näher
Stuart Morgan
Catalogue Galerie Grässlin-Ehrhardt, Frankfurt 1987
Text edited

Bettina Gruber/Maria Vedder
Der Herzschlag des Anubis
(The Heartbeat of Anubis)
by Bettina Gruber and Maria Vedder
Friedmann Malsch
Catalogue, Third Marler Video-Kunst-Preis, Marl 1988
Skulpturenmuseum Glaskasten

Rosemarie Trockel
The Resistant Art of Rosemarie Trockel
Jutta Koether
Artscribe International March/April 1987
Text edited

Klaus vom Bruch
Analysis situs: Adnote to the Amplitudization of Space
David Niepel
Translated by Hilary Heltay
Radarraum catalogue
Exhibition 11 September-23 October 1988
Städtisches Museum Mönchengladbach
Abteiberg

Marcel Odenbach
The Form My Gaze Goes Through
Raymond Bellour
Afterimage November 1988
Text edited

Walter Dahn
A Thread of Ariadne Through the Pictorial Conception of Walter Dahn
Siegfried Gohr
Walter Dahn, published by Buchhandlung Walter König, Köln 1988

Thomas Locher
The World in Pieces
Stuart Morgan
Artscribe International September/October 1987

INTRODUCTION

Lewis Biggs
Curator of Exhibitions
Tate Gallery Liverpool

Why Cologne? The reasons for making an exhibition to focus attention on contemporary art from Cologne are more than adequately argued by Lucie Beyer and Karen Marta, in the essay which follows. They, and Hein Stünke, bring an insider's knowledge to their valuable descriptions of the present structure and historical background of the Cologne art world. In selecting the exhibition, however, I have been conscious of my position as an outsider. My aim has been to pass on to the public in Britain my excitement at discovering the energy, confidence, passion and quality of the art being made in Cologne.

This aim immediately differentiates *Art from Köln* from two other recent exhibitions, seen only in Cologne, which also took the city as their starting point. *Made in Cologne*, the opening exhibition at the DuMont Kunsthalle, was selected by Professor Klaus Honnef to show new work by 25 artists, all of whom are well recognised locally as personalities. *Kölnkunst*, at the city's Kunsthalle, gathered 100 participating artists chosen from an open submission of 700 groups of work. According to one of the organisers, there are perhaps 2000 artists living in the city. Faced with such abundance, my task of selection during several visits over six months was daunting.

The selection was made on the basis of a personal reaction to the quality of the work that I saw and my personal belief in the project of the participating artists. I wanted to respect the individuality of each contributor, but still leave room for some possibility of shared interests. The only restriction on the selection, apart from the space available, was that the artists should be currently living in Cologne. This is not an arbitrary distinction. Artists from other parts of the world who show in the important Galleries and with the enterprising dealers of Cologne are clearly vital to the city's artistic standing. Nevertheless it is the artists who live there who ultimately make the 'scene' what it is.

The dealers and their 'stables', the recent history of art in Cologne, the 'generations' and *'Klüngels'* upon which Karen Marta and Lucie Beyer concentrate are fascinating and significant. They are a key to understanding how Cologne has built its current pre-eminence, but it would have been impossible to design an exhibition to communicate these subtle and multiple relationships to a public in a foreign country. From the perspective of an outsider, they seem less important and less striking than the qualities mentioned earlier: the diversity, the energy, the confidence and the passion of the city's art scene. Perhaps Cologners take these things for granted, but to the visitor they are astonishing. It is they, and not the local artworld politics, which allow Cologne to project itself as an artistic metropolis, and which guided the selection of this show.

There is no recognisable 'school of Cologne', and of course the character of any city may have no discernible effect on the individual artworks made by an artist living there. Yet in attempting to characterise the impact of the city's art scene, it is the metaphor of the life of Cologne itself which comes to hand as having the greatest explanatory value. My understanding of the city has of course been influenced by all those people who have been kind enough to show me around.

The ambience of the city is relaxed, unsnobbish and unbeautiful. The cost of living is relatively cheap. There is enough of the Latin about the streets for people to feel comfortable staying talking around the table on the pavement after finishing their meal. As a friend from Düsseldorf remarked, with a hint of envy: 'There is always the Cathedral. You can sit and have a beer.' The tradition of the Carnival is very strong. Carnival is when the ordinary world suddenly becomes extra-ordinary. It is this magical sleight of hand which artists use at will. Carnival is concrete evidence that this world is, as Friedmann Malsch's text printed here says, 'a puppet-house of images'. Cologners believe in having fun. Not only is fun important, but it is equally important that everyone should join in. The currency of the latest joke, which may be intricate and many-layered, is a password among friends. The seriousness with which Cologners treat humour, and even slapstick, is sometimes disconcerting to outsiders, particularly when it is incorporated into art.

The history and geography of the city – a Roman frontier town, then an independent city state, and always a busy trading town on a crossroads of Europe – have made it cosmopolitan, democratic and tolerant. In many German cities, like Cologne's near neighbour Düsseldorf, for instance, the art world revolves around the School of Art or Academy. In Cologne, the lack of a strong institutionalised art school has meant that there is no recognised orthodoxy in art, any more than the city has in religion. Manifestations of power elicit a less tolerant attitude, ranging from gentle pastiche to vicious satire. For instance, American culture in the late fifties and sixties, and particularly American art as shown by the big galleries and in the early art fairs, was seen to be a powerful, institutionalised orthodoxy. This apparent threat to Cologner's sense of individualism produced a strong, cohesive reaction in the art world, and made Cologne a centre for Fluxus and neo-dada.

Despite the relaxed atmosphere of the city, artists in Cologne can be intensely competitive, vying to have the 'edge', the last word, or the last laugh. But the intensity of this individualism is offset by the mutual supportiveness which often merges into active collaboration (in this exhibition, for instance, between Bettina Gruber and Maria Vedder) in making artworks, publications or exhibitions. *Fröhlichenanarchisten* (joyful anarchism) is a word which seems appropriate to combine both the radical and passionate sides of the Cologne character. A strong social awareness, clearly evident in the work of Sander and Chargesheimer, combines with a love of beauty to produce a prevailing and multi-layered irony which is sometimes hard for an outsider to appreciate. The use by many artists of journals and diaries points to an intimate and personal approach to art, and autobiography along with role playing and mask-making form a springboard for performance, photography and video. Above all, there is a sense that attitudes, beliefs and discussions – that is to say, people – matter more than material objects or styles.

Since this catalogue contains a short piece of critical writing on each of the artists, it is unnecessary to comment further here on the work of individual artists except where it seems relevant to the selection as a whole. Although the exhibition is principally about the contemporary situation, it seemed justifiable to include work by two dead artist-photographers whose work seems deeply rooted in the life of Cologne. Sander and Chargesheimer were both exceptionally fine artists who held up a mirror to the city and helped it to see itself. Sander's work exemplifies a democratic respect for the individual and for popular culture, while Chargesheimer's breathes a passionate dislike of authoritarianism and a scepticism about institutions. Both Chargesheimer's eye and his sense of irony in particular form a useful yardstick for the work of many currently more fashionable artists who use photography to similar ends.

Gerhard Richter, in his attention to the philosophy of art as a distinct category, and Sigmar Polke, in his refusal to simplify art's complexities, occupy in their different ways positions at the heart of the discussions about art current in Cologne. The quality of their work and the stimulation of their presence is a spur to other artists. It seems poetically just that Polke should now live in the street whose spirit formed the subject of one of Chargesheimer's most celebrated projects. The work of both Walter Dahn and Rosemarie Trockel in different ways may be seen as building on the foundations of a 'social art' laid by Joseph Beuys, although their contributions are refracted through the subtle lens of Cologne.

The work of Christa Näher, Hubert Kiecol and Thomas Locher may appear to owe nothing to the climate of Cologne, and yet it is precisely this that makes it so relevant to the aims of this exhibition. For it is from the hospitable platform offered by the city that they have chosen to mount their critiques of recent (American) art. Näher, by establishing her roots in a European romantic tradition makes a reassessment of 'sublime' abstract expressionism. Kiecol makes a reappraisal of American Minimalism through his historically-aware interest in monumentality. And Locher, in common with other artists now based in Cologne, calls for a

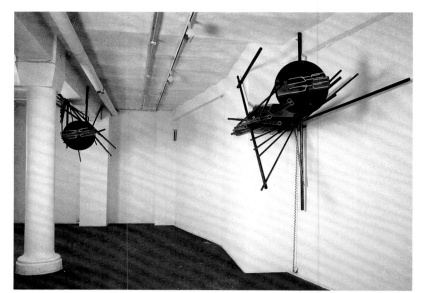

KLAUS vom BRUCH
Attack and Defence

re-consideration of American Conceptual art. The high degree of artistic awareness in Cologne ensures each of these artists the public he or she requires.

Group shows rarely do justice to the individual participant's work. This exhibition, for reasons of space, gives no indication of Chargesheimer's sculptural work, for instance, and is particularly unjust to three artists – Ulrike Rosenbach, Marcel Odenbach and Klaus vom Bruch – each of whose work properly involves several media, but who are here represented only through single-monitor video presentation. Rosenbach first acheived international recognition as a performance artist. Odenbach makes drawings and collages, as well as video installations. Vom Bruch also makes environmental video installations with a strong sculptural component.

As might be expected, Cologne's visual artists often practise other arts as well. Bettina Gruber, for instance, is a composer, while Walter Dahn sings with The Jewellers. To recreate a sense of the city's energy the exhibition would have had to be accompanied by a programme of concerts and readings at least in addition to the conference that has been organised. Finally, there is no substitute for visiting the city and becoming involved with its artistic life. I am grateful to all the people I have met in Cologne (some of whom are acknowledged on page 6) who gave me this opportunity.

WHY COLOGNE?

Lucie Beyer and Karen Marta

Why Cologne? For some time now Cologne has been an essential stop on the European culture itinerary. The most obvious attraction for the visitor interested in contemporary art is the new Ludwig Museum, opened in 1986. In addition, the city plays host to the most important of the German art fairs, Art Cologne, and supports a thriving concentration of galleries. There is also Cologne's growing reputation as an art centre. It remains (with West Berlin) the locus of German Neo-Expressionism, though the movement itself has become unfashionable. Cologne is also home to some of the most provocative new art being made in Germany today.

The centre of Cologne is small, and it is easy to find one's way around. The city itself is ugly, the only one of its size in West Germany to have gone so long without repairing the war damage that spared only a few Romanesque churches and the Cathedral. Cologne's slowness in entering the *Wirtschaftswunder*, 'economic miracle,' and the postwar reconstruction is a manifestation of its inhabitants' relatively relaxed attitude toward life (by German standards). Cologners are famous for their unusual tolerance of foreign cultures and proud of their eccentrics, individualists – and artists.

And indeed, in the battle for cultural supremacy in the Rhineland, Cologne appears to have succeeded in vanquishing its arch rival, Düsseldorf, which had already played a major role in the 19th century with its prince and art patron Jan Wellem, its internationally influential academy of art and such painters as Peter Cornelius. In the 20th century, Düsseldorf was a key centre of Expressionism, and continued to be the site of innovative activity on up to the days of Fluxus and Joseph Beuys.

In the 60s, when the Fluxus avant-garde, the Nouveaux Réalistes and American Pop art were creating a furore in Düsseldorf, Cologne responded with its own burgeoning underground, which assumed a leading role in new music (eg Karlheinz Stockhausen, Bernd Alois Zimmermann), experimental rock (eg The Can) and avant-garde literature (eg Rolf Dieter Brinkmann). In 1967 the Cologne dealers Rudolf Zwirner and Hein Stünke founded the *Kunstmarkt* ('art market'), which later developed into today's fair, Art Cologne. Düsseldorf started its own fair in 1972, which it alternated with Cologne's until 1983, when Cologne's fair prevailed. Düsseldorf's Kunstakademie continued to exert great cultural influence throughout the 60s, but then in 1972, Beuys was expelled from it for his radical political activities and his challenges to the academy's authority. (Interestingly, Johannes Rau, the culture minister responsible for the dismissal, is now trying, as State President of North Rhine Westphalia, to claim Beuys's work as part of the cultural patrimony.) Blinky Palermo died in 1977; Ulrich Rückriem, Sigmar Polke and Gerhard Richter moved to Cologne. By the end of the 1970s, Jörg Immendorff was the most influential artist remaining in Düsseldorf. Immendorff surrounded himself with a group of new, young artists, whom he presented in a 1979 exhibition in his studio called *Finger für Deutschland* (*Finger for Germany*). The artists who emerged from this exhibition – Albert Oehlen, his brother Markus, Werner Büttner, Hubert Kiecol, Georg Herold and Christa Näher among them – went on to establish careers for themselves in the burgeoning Cologne art scene.

Fortunate in its geographical situation – not only equidistant from West Germany's major cities but also relatively close to Brussels, Paris and Amsterdam – Cologne first developed a reputation as a pre-eminent business centre; this then made it easy for the city to establish itself as an art market. A network of galleries formed rather quickly. Rudolf Zwirner, who still deals in blue-chip art, began to show American Pop art in the early 60s. Rolf Ricke opened his gallery in 1967, featuring the work of such American Minimalists as Gary Kuehn, Richard Serra and Keith Sonnier, though he exhibited the sculpture of Ulrich Rückriem and other German artists as well.

Not everyone in Cologne, however was so eager to jump on the capitalist bandwagon. In the heady atmosphere of political radicalism of the 70s, people like Beuys and Fluxus artist Wolf Vostell, though based in Düsseldorf, protested against Cologne's growing art market. In 1969 Beuys, Vostell, Klaus Staeck and Heinz Rywelski held an anti-art fair, to

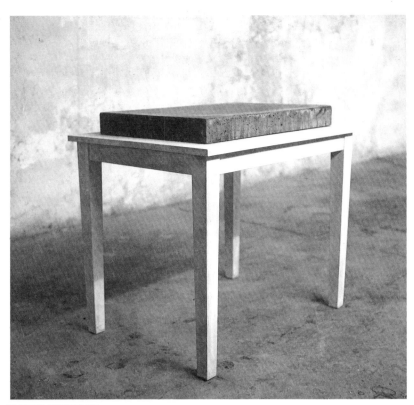

HUBERT KIECOL
Cloud 1986

WALTER DAHN
Untitled 1987

coincide with Art Cologne, in a large tent in the heart of the city. Similarly, Friedrich Heubach, today an important psychologist and theorist, criticized the commercialism of the avant-garde, and championed the work of Beuys, Polke, Broodthaers and others in *Interfunktionen*, an art journal that was extremely significant in the late 60s and early 70s.

Despite their intensity, such counter-cultural critiques gradually died out as the 1970s went on. Art's general development, in the late 70s, toward painting and commodification, fitted perfectly with the new mood in Cologne (and elsewhere). At the decisive moment of transition from purportedly uncommodifiable work back to an art of objects – of products – many of the city's leading dealers secured for themselves the sponsorship of the up-and-coming generation of figurative painters. As an art centre, Cologne profited from this stroke of commercial acumen and from the presence of the new artists.

The art establishment in Germany tends to be dominated by the art academies, which did not wither in the modern period as they did in Paris and most other Western European art centres. It is part of the institutional effect of the art academies to bring artists together. Mature artists orbit in the academy's gravitational field, attracted by the support system that it offers in the form of professorships. The academy also creates a web of relationships among students, and between students and teachers, and these relationships tend to coalesce around strong figures who represent clearly defined artistic traditions or intellectual positions. When Beuys, for example, was teaching in Düsseldorf, the Kunstakademie was a focal point of the Fluxus movement in Europe; today, 20-odd years later, one still hears this or that artist, who may have only sat in on his classes, described as 'a pupil of Beuys'. Despite (or perhaps because of) his iconoclastic position, Beuys became the centre of an old-boy network based around the academy. Such networks perpetuate themselves from generation to generation, tending to monopolize galleries and museums in their geographical area.

The situation is different in Cologne. Perhaps uniquely in West Germany, Cologne has no academy. Consequently, it has never generated the type of small, tight constellations around major artists that flourished at the Düsseldorf academy. Generally speaking, Cologne generates a broader, looser, more indeterminate kind of alliance – what is known in local dialect as a *Klüngel*, an informal, unspoken treaty of support between a group of people with like interests. Most often, the *Klüngel* centres on the artists of a particular gallery, but not exclusively; there are frequent collaborations among artists from different galleries, and much movement between groups; some widely respected artists, like Polke or Richter, remain unaligned. As much as anything else, the *Klüngel* is a social set, whose meeting place is the bar, an institution with its own rules and culture. Swords are supposedly left at the door, though 'discussions' over seemingly small points of difference can certainly look like heated arguments to an outsider.

Though the Cologne art scene is less monolithic, and its internal boundaries are more permeable, than those of many academy cities, the gallery system it substitutes for the rigid hierarchies of the academy in some ways duplicates them – at least in terms of providing an institutional structure. The *Klüngels* are often reconstitutions of artists' groups formed in the academies of other cities which have moved wholesale to Cologne in pursuit of a commercial base. The core group of artists at the Hetzler Gallery, for example – Georg Herold, Albert and Markus Oehlen, Werner Büttner, Hubert Kiecol and Martin Kippenberger – all studied at the Kunstakademie in Hamburg; many of the artists at the Tanja Grünert Gallery – Thomas Locher, Rolf Walz, Peter Zimmerman and Thomas Grünfeld among them – have known each other since their student days in Stuttgart. One could say that the history of Cologne as an artistic city is, in fact, the history of many different groups which have come to it from elsewhere.

The situation with the Michael Werner Gallery is more complicated, in

that its major artists came to it from extremely different backgrounds and few of them actually live in Cologne. Yet the Werner artists – George Baselitz, Markus Lüpertz, A R Penck and Jörg Immendorff in particular – are in some way the prototypical Cologne *Klüngel*, and Werner, with his strong commitment to them and their positions, may be the prototypical Cologne dealer.

The roots of the Werner group go back to 1961, in Berlin, when Baselitz came into Rudolf Springer's gallery and asked Werner, who worked there, to hang a manifesto. (Baselitz and Penck are both of East German origin; Penck, though he showed in the West, lived in Dresden until 1980. Lüpertz was born in Czechoslovakia.) Baselitz's wife introduced Werner to Penck and Lüpertz in the late 60s, just before the dealer moved his gallery to Cologne because he felt 'that something could develop there.' Penck's first solo show in the West was with Werner in 1969. Immendorff, who became friends with Penck in the early 70s, joined the gallery soon after. Werner says that he's not interested in the conceptual side of painting, but rather in what one could call its emotional aspects: painting that is self-reflexive, addressing its own, particular, underlying problems. This is certainly true of Baselitz and Lüpertz – and of Kiefer, who left Werner for Paul Maenz in 1980.

The core group of artists from the Werner Gallery, most in their late forties, are all well established by now, with work in major German museums, and they serve as role models for a younger generation of German artists. They all teach: Penck in Düsseldorf, where Lüpertz is now director of the Kunstakademie, Immendorff in Munich and Hamburg, Baselitz in Berlin. Each has, over the years, come to represent a particular tradition of German painting – eg, Immendorff, the allegorical social realist, or Lüpertz, the pasticheur of Germany's past refracted through modern art history – and they take their positions seriously.

But it is not only their work which looms large on the German art scene. Also important is the public image of the Werner artists, a persona so often copied that it has practically achieved iconic status: the artist as exotic, black-leather clad, silver-beringed dandy. Together they are seen as a gang, making public appearances at openings and at restaurants and bars. Immendorff himself frequently deals with the public and private life of the Werner *Klüngel* in his paintings and sculptures, taking it as an amusing continuation of his examinations of the Communist party from his early days as *artist provocateur* at the Düsseldorf academy. In a 1987 painting, 'Nachtmantel' (Night Overcoat), Immendorff, with a mixture of *braggadocio* and humour, paints all the art world as a stage, and himself in pink toe shoes, log-rolling on a divided Germany, an allusion to his 'Café Deutschland' series. In the audience, as brightly lit as the stage, is a gathered host of art-world luminaries – from Rudi Fuchs and Siegfried Gohr (director of the Ludwig Museum) to Mary Boone, the Werner gang, Julian Schnabel and David Salle – who appear, as interested in being seen as in watching Immendorff's painterly performance. Waving good-bye as he walks out is Joseph Beuys. The cult of the artist's image which the Werner group has developed is powerful, even if such posturing has contributed to their being regarded, in some circles, as caricatures rather than as major national figures. While it is difficult to support the oft-repeated claims of the major influence Penck, Lüpertz, Immendorff and Baselitz have had on the extremely heterogeneous younger generation of painters, they do seem to have provided the likes of Rainer Fetting, Walter Dahn and Werner Büttner with a model of what it means to be an artist today – in terms both of persona and production.

At the opposite pole from the Werner group is Paul Maenz's. Maenz has been resident in Cologne since the early 70s. He played a role in establishing Minimalism and Conceptual art in Germany (in competition with the Düsseldorf gallery Konrad Fischer), then Arte Povera and finally the painting of the Mulheimer Freiheit group (Peter Bömmels, Georg Jiří Dokoupil, Walter Dahn, Hans Peter Adamski, Gerard Kever and Gerhard Naschberger). Maenz was the first in Germany to show Cucchi, Chia and Clemente. His influential early show 'Mulheimer Freiheit and Other Interesting Pictures from Germany' supplemented the original group with Albert Oehlen and Werner Büttner, who although they were also painters, started from a more conceptual-political position than the 'spontaneous' Mulheimers. Maenz was very quickly able to market this group of Cologne painters, who took their name from a street in a suburb where they shared a studio. In fact, three of the six (Bömmels, Dahn, Dokoupil) became stars.

Bömmels has stood somewhat alone from the beginning. An autodidact, his work is heavily determined by his radical, populist politics and philosophical interests; he has always been active in other fields, and in 1980 was one of the founders of the avant-garde music and art magazine *Spex*. Bömmels began making paintings and sculptures in the same year. His paintings, part surreal naïveté, part psychodrama, are quite earnest, metaphysical musings on the state of modern Germany. His sculptural work, on the other hand, has become increasingly influenced by the Catholic tradition of his native city, Frauenberg, and refers to Romanesque and medieval sculpture, as in his sandstone narrative frieze, 'Sieben Steine zur Lage' ('Seven Stones Take a Position', 1986-87), which the Ludwig Museum recently bought.

Dahn – Beuys's most prominent pupil of the punk generation (he was born in '54) – and Dokoupil – the man who changes styles – collaborated for a while despite very different individual positions. Dahn, romantic ironist though he is, maintains a Beuysian preoccupation with politics and process, while Dokoupil's concern is with the game of style. The 'Ricky' pictures, one of their best co-productions, began as a parody of a canvas by the Berlin-based Neue Wilde painter Rainer Fetting, a well-known homoerotic scene entitled 'Ricky Under the Shower'. In the Dahn/Dokoupil series, absurd objects like a kitchen stove replace the young man in the shower stall in Fetting's work. Later Dahn and Dokoupil themselves became the victims of a spoof by another artist, Martin Kippenberger, who is particularly skilled at this typically German – especially Cologner – art-world game of one-upmanship.

In 1984 the two collaborated on the 'Africa' series, a mock-Picasso-esque body of work inspired by African tribal art, which was accompanied by a jointly produced catalogue. Soon after, Kippenberger published a catalogue identical to Dahn and Dokoupil's in its cover and layout, with an essay by the author who wrote theirs (Wilfried Dickhoff). The art in the catalogue dedicated 'to Georg and Walter', was, however, in Kippenberger's usual ironic 'bad-painting' style. Such goings-on may be typical of Cologne, but they are also symptomatic of the efforts of many young German artists to make clear the incompatibility of their various conceptions of painting, despite their frequent linkage in the media.

For none of these artists, except perhaps those from Berlin, has painting as painting ever been an end in itself. Their concerns are primarily conceptual and political. How is it possible, they seem to ask, to find new content, after Conceptual art, performance art and the dogmatic left all failed to initiate any long-lasting social change? To some, the issue is not so much what kind of content is possible, as whether any is possible at all. Such questions, extreme enough in themselves, are made more complicated by the burden of Germany's history: the need to face the past, but the difficulty of doing so given the legacy of guilt, and the fact that Nazism, in appropriating for itself so many of the traditional elements of German culture, has sealed them off from acceptable use.

Perhaps the most cogent answers to this artistic dilemma among younger artists have been provided by Georg Herold and Albert Oehlen. Herold's three-dimensional pieces, often shabby and simple, ask questions about content through their very unlikeliness. His 'Lost Territory' series (1985), a group of paintings made of roofing lath and canvas suggests the torn fabric of postwar Germany, and metaphorically speaking, the hastily stitched together map which represents its divided condition. Oehlen, for his part, often trades in taboo subject matter – portraits of Hitler, the

THOMAS LOCHER
I–Z 1988

swastika and other Nazi insignia – which he re-presents in formalist terms, brutally distancing the viewer from a conventional response.

Both Herold and Oehlen are part of the *Klüngel* centring around the Hetzler Gallery. Hetzler came to Cologne from Stüttgart in 1983, and ran his gallery initially with Bärbel Grässlin (who now has her own space in Frankfurt). With him came Kippenberger, who, among other activities, had run an 'office' in the loft he shared with Gisela Capitain in Berlin in the late 70s. It was there in 1978 that he and Capitain staged a landmark exhibition, 'Elend' (Misery), which introduced the work of, among others, Oehlen and his brother Markus, Herold, Büttner, Ina Barfuss and Thomas Wachweger, a year before Immendorff brought them to prominence as a group with his *Finger für Deutschland* show in Düsseldorf. Capitain later became Hetzler's assistant, and today has her own Cologne gallery presenting the graphic work of Hetzler artists and others, including Christa Näher and the Austrian Heimo Zobernig.

Hetzler's artists perhaps even more than Werner's and Maenz's, appear together in communal situations. They frequently collaborate and, until quite recently staged regular joint exhibitions: the record *Rache der Erinnerung* (*Revenge of Memory*) has on it performances by Albert Oehlen, Kippenberger and Büttner, as well as by Penck and Immendorff; the catalogue *Wahrheir ist Arbeit* (*Truth is Work*) is a group manifesto written by A Oehlen, Kippenberger and Büttner; the exhibition *Können wirvielleicht unsere Mutter wiederhaben!* (*What About having Our Mother Back!*) featured the work of Büttner, A Oehlen and Herold.

For the past two years Büttner and A Oehlen have had their own publishing house, Meter Verlag, which will publish books until the spines of the collected volumes cover a distance of one metre. The texts are mainly their own Büttner's *In Praise of Tools and Women,* Büttner and A Oehlen's *Angst vor Nice* (*Fear of Nice*), Kippenberger's *Café Central*, as well as works by friends working in other media who support the work of the group or engage with it critically: Diedrich Diederichsen, the editor of *Spex*, and the musicians Mayo Thompson and Sven Ake Johanson. Recently, Oehlen was guest editor of an issue of the Austrian art journal 'Durch', in which he asked his friends, and other artists and writers he admires, to discuss what is, to him, the most pressing art-political question – how, or whether, one can be a radical artist in the late 1980s. There were essays about Guy Debord and Asger Jorn, a monologue by Immendorff and texts by Michael Krebber, Rainald Goetz and Martin Prinzhorn.

If the Hetzler Gallery may be said to represent the legacy of political art, Monika Sprüth's represents the legacy of feminism. Sprüth shows many women artists and has, over the past two years, produced two numbers of *Eau de Cologne,* a magazine devoted to women artists. She has also championed American women artists such as Jenny Holzer, Barbara Kruger, Cindy Sherman and, more recently, Gretchen Bender and Annette Lemieux. Sprüth's commitment is all the more important in view of the fact that in Germany, in contrast to the US, there is a discernible absence of a developed feminist critique. This situation certainly has something to do with the revival of the image of the artist as macho dandy. In *Eau de Cologne,* Sprüth and her collaborators have, in the best materialist tradition, explored the roles of women artists, curators, dealers, critics, etc in a male–dominated art world. (Sprüth also shows several male artists – Andreas Schulze, the Swiss duo Fischli and Weiss and the American George Condo among them.)

One of Sprüths's core artists is Rosemarie Trockel. Even though Trockel has never explicitly proclaimed her feminism, it can't be over-looked or ignored, especially in her knitted wall pieces, or her recent sculptures that incorporate female body parts, the latter shown last summer at the Basel Kunsthalle. Trockel has achieved something remarkable for Cologne, with its groups, cliques and factions: her work appeals to a broad range of people and for very different reasons. This may have something to do with her flexibility regarding the use of materials: for Trockel, as for Beuys, what is important is the process of art-making itself. Hers is an open system, continually embracing new ideas, and the objects

she makes – sculptures, drawings, wall pieces – survive as the artifacts of her investigations. Such suppleness and ambiguity permit the knitted wall pieces, for example, to be claimed by some as a critique of the commodity system, by others as a feminist elevation of traditional woman's work.

Katharina Fritsch is the other young German woman artist to have risen to international prominence recently. Her work was, in fact, shown with Trockel's in Basel. Fritsch's art stems from chains of ideas that cohere intellectually but not necessarily stylistically. She attracted attention last year with her enormous green elephant shown in the museum in Krefeld, and with her yellow Duroplast Madonna in the outdoor *Skulptur Project* in Münster – a piece that so disturbed the populace it was vandalised twice. Fritsch's unaffected, direct transpositions of familiar objects, which take on iconic status at monumental size, afford the greatest conceivable contrast to Trockel's intricate systems.

Fritsch shows with the gallery of Johnen & Schöttle, which also exhibits a number of artists drawn from the Düsseldorf Kunstakademie pool – including Ludger Gerdes, Thomas Huber, Thomas Ruff, Stefan Balkenhol and Martin Honert. Ruff, a pupil of Bernd & Hilla Becher, has made a name for himself with large, ambiguous portraits of figures on the Düsseldorf art scene; Balkenhol, who makes near-life-size painted wooden figures in a naif, realistic style, studied with Ulrich Rückriem. The dealer Jörg Johnen sees his artists as sharing a rejection of cynicism and of an anti-art stance; he champions optimism, he says. Johnen's artists also demonstrate a dedication to craftsmanship and precision – along with a self-reference that borders on the solipsistic. Personal history is transformed, in the work of these artists, by an elaborate, almost monstrous formalism that gives their works a classic, timeless quality – at first glance. Looked at more closely, however, a piece like Honert's 'Kinderkreuzzig' ('Children's Crusade'), 1985-87, a medievalizing, historical pageant in polychromed polyester that literally steps off the wall, appears conventional, over-particularized and marred by a nostalgic historicism.

Most of the artists at the Tanja Grünert Gallery have known each other since their student days in Stuttgart, and followed the gallery when it moved to Cologne in 1984. Whatever medium they use, Thomas Locher, Rolf Walz, Peter Zimmermann and Thomas Grünfeld all share a conceptual bias and a well-developed feeling for perfect surface execution. Only slightly younger than the Neue Wilde painters, they are not opposed to the 'new painting', and may even have experienced it as in some ways liberating; still, they have a close relationship with certain conceptually inclined American artists – Joseph Kosuth, Lawrence Weiner and Donald Judd, for Locher; Richard Artschwager, Neil Jenney and Edward Ruscha (whom Grünert has shown), for Grünfeld.

But if inspiration is American, it is transformed in its application to German material – in Locher's case, linguistic systems and philosophy, in Grünfeld's, German taste in furniture, 1950-60. Overlaying Grünfeld's obvious references to Artschwager and his enthusiasm for American Pop art is a taste for the dandyish charm of English men's clubs and the stuffiness of the old Cologne, near the Rhine, where the artist grew up.

Grünfeld provides an interesting example of the mixing between *Klüngels*. He has a close relationship with Friedrich Heubach, the former editor of *Interfunktionen,* and also with Hetzler artist Georg Herold, whose work might seem diametrically opposed to his own. Grünfeld makes perfectly crafted objects that maintain an aura of the precious art object, while Herold takes an anti-art position, using crude and simple materials. Yet both are concerned with how art works are defined within a cultural system, a subject Heubach has addressed in his writing. The two artists recently collaborated on a catalogue, *1:1* (1978), which has a text by Heubach.

Last year saw a challenge to Cologne's standing as an art capital. The city of Frankfurt, Germany's wealthy financial centre, lured the curator Kasper König to head the Städel school and to run the Portikus exhibition space there; he took with him a number of teachers – including Gerhard Richter, Per Kirkeby, Christa Näher and Ulrich Rückriem. In 1989 Frankfurt plans to inaugurate its own annual art fair, indicating a serious financial commitment to the art market; Frankfurt's soon-to-open contemporary art museum, with its considerable buying power, is also seen as a potential threat to Cologne's cultural dominance.

But Cologne may not be so easily daunted. Last spring a new gallery building opened, with large open spaces on each floor à la SoHo. There followed a wave of activity – some galleries moving, new ones opening up. Former Ludwig Museum curator, Rafael Jablonka, opened a gallery showing a mixed programme of American art (Richard Prince, Carroll Dunham), some of his German favourites (Maria Zerres, Michael Bauch) and several artists primarily associated with other galleries (Gunther Tuzina, who shows with Gisela Capitain, and Fritsch). The Galerie Isabelle Kapczak will be moved from Stuttgart to Cologne in January 1989. The city has a new private Kunsthalle as well, the brain child of Cologne newspaper publisher Alfred Neven DuMont. Sited in an industrial complex in the north of Cologne, the 21,500 square foot hall will in DuMont's words be 'a forum of contemporary art'. The DuMont Kunsthalle's first show, *Made in Cologne,* August-November 1988, featured the work of 25 resident artists, Penck, Polke, Dokoupil and Dahn among them.

And the *Premierentage* of Spring 1988 was the best attended ever. Begun in 1981, this biannual event, which coordinates a day of simultaneous openings at the city's 70 galleries, has played a major part in expanding the Cologne audience for art (the model has been taken up by other German cities). In the relatively small city centre, thousands of viewers swarmed from one gallery to the next. The bars filled up, and business was concealed behind thick, beery clouds of friendliness, belying, for the moment at least, the celebrated factionalism of the Cologne art scene.

THE COLOGNE KUNSTMARKT

Hein Stünke

It is now more than twenty years since the first Kunstmarkt was inaugurated in Cologne's Gürzenich, the town's medieval banqueting hall, sparking off an unusual degree of interest and surpassing all its organisers' expectations.

Since that date we have divided the history of the more recent art into two periods, pre- and post-Kunstmarkt. The changes affecting not only artists and collectors, but also the modern art trade, were as far-reaching as they were unexpected. That the idea of an art market had a certain fascination at that time is clear from the fact that the Cologne model was swiftly successfully imitated elsewhere. Of course, there were also people, both at home and abroad, who thought it tactless to make art publicly accessible through the marketplace. Voices were raised in opposition to the idea. But by far the most vocal of all these critics was Henry Kahnweiler, one of Paris's leading art dealers, who rejected the project out of hand. For him the mere association of the words 'art' and 'market' was a source of scandal, and the whole venture deemed to be symptomatic of an incipient decline in 'good taste'. Kahnweiler's idealistic training prevented him from seeing that it is entirely legitimate to speak of the artistic value and monetary value of a work of art, and that monetary value does not imply that the artistic value is thereby impaired.

Kahnweiler found himself overtaken by events. When the second Kunstmarkt opened its doors, this time in Cologne's Kunsthalle, it was already substantially the same organisation as still exists to this day. Only in the number of its participants has it grown: at the first Kunstmarkt (1967) there were eighteen galleries, whereas the present number is around 160. (The number of foreign galleries has remained constant at between 20 and 30 per cent.)

When one looks at this success and at these figures, the question is bound to be asked how this development came about and why Cologne in particular became the centre of Germany's fine art trade.

There were various factors which favoured Cologne and encouraged the remarkable development in the modern art market that has taken place in Germany since the end of the war. The most important of these factors were political, economic and geographic, although local history also played a part. Last but not least was the preferential treatment that Cologne received after the war as a result of the arbitrary division of Germany and resultant isolation of Berlin. It was no longer possible to build up a market in modern art in the country's former capital. As a result, a decision was taken to concentrate on Cologne, where there were already a number of leading private collectors and several outstanding public collections. They were collectors of standing, of a kind that no longer existed in Berlin after the war. There was also the favourable economic and geographic position of Cologne, which had been a member of the Hanseatic League since 1201. The town's proximity to Holland and Belgium, France and England made it an ideal trading centre: general economic links were swiftly forged with all these countries, while close ties with individual galleries and artists followed shortly afterwards. Artistic productivity was relatively quick to revive in post-war Germany, but galleries specialising in modern art were initially dependent chiefly on imports which, in the main, came from France and from the end of the 1950s, from England.

Sales increased from year to year until, by the early 1960s, a number of young American artists, especially Pop artists, were also beginning to make a name for themselves on the German art scene. As foreign products continued to proliferate and penetrate the German art market, so production increased in Germany, too. It had developed after the war under the same difficult conditions as beset the fine art trade in general, but local products now won an increasing share of the market and came to enjoy a certain international reputation. This was certainly a welcome development, although the position of the new galleries at the beginning of the 1960s could still not be described as brilliant. The market continued to be dominated by dealers brought up on a diet of classical modernism. By the mid-sixties, therefore, people were beginning to ask how a proper market could be created for new art, and at the same time, how Cologne

could be turned into a leading centre for modern art. The planners were encouraged and spurred on by the favourable conditions that obtained in Cologne, for the intervening years had witnessed the formation of a circle of young collectors, art lovers and connoisseurs of modern art in the town. And it was fortunate – not to say a stroke of supreme good luck – that the town had an arts administrator who, in the very first discussion about the projected Kunstmarkt, gave the plan his enthusiastic backing and granted the Union of Progressive Art Dealers credit facilities with which to underwrite the first Kunstmarkt. The result was something which surpassed everyone's wildest dreams and expectations. And whereas it had initially been genuinely difficult to find eighteen galleries in the whole of Germany to participate in the first year's event, there were already eighteen galleries in Cologne alone by the time the first Kunstmarkt finally closed its doors. Since then the figure has increased by the year and now stands at over one hundred.

Whereas Cologne had already distinguished itself with a series of outstanding major exhibitions of modern art even before the First World War, a climate once again developed which, supportive of the arts, drew more and more artists to the town, encouraging collectors and allowing the city's galleries to undertake work that was as exemplary as it was successful.

The close contacts between dealers, artists and collectors that developed during the 1960s and 1970s still exist today. By helping and encouraging each other they aim to enable all concerned to work as efficiently as possible for the benefit of every single individual and for the good of the whole community.

Two collectors in particular have promoted this aim through the manner and substance of what they have collected. Through the manner of their approach to collecting they have exerted an influence on artists and dealers, but also on younger and older collectors who, in turn, have left their mark on Cologne's artistic landscape. Particular mention must be made here of Wolfgang Hahn who, until his recent death, had pioneered a particular form of collecting. Even while still a young student he had collected art: it was a passion which he cultivated right up until his death. His feel for art was directed at young artists whose talent he discovered at an astonishingly early age and whose careers he followed over the years. Not content with that, however, he bought their early works and remained at the same time a critical yet sincere patron. Hahn played an important role in Cologne, as important as the influence he had on what is called the Cologne scene.

One of Hahn's fellow collectors is Peter Ludwig. He is an industrialist and goes about collecting art much in the style of a big businessman. A memorial to him was erected at an early date with the opening of the Ludwig Museum. Not only is he an emperor by nature, he has also become one through the style of his collection. He aims to collect every kind of art, both classical and modern. His active interest takes him to the forefront of recent art. The evidence of his passion for collecting is, of course, to be found not only in Cologne, but also in Kassel, East Berlin and Vienna, Paris and Aachen. It is not difficult to see that a man of his stature is bound to have left his mark on the artistic life of Cologne.

There is one particular feature of the artistic life of the town – at least as far as the fine arts are concerned – which deserves to be mentioned here. The town pays for study trips and grants scholarships, it also occasionally buys works of art and awards public commissions; but all in all it can offer only limited help. Even the provision of studios at favourable rents is insignificant and it remains to be seen what will happen in this direction in the future. But the city's artists receive massive support from collectors and dealers, so much so that more and more artists are drawn to Cologne, with the result that, although it does not boast a College of Art, Cologne has now become a city of artists.

What people are fond of calling the Cologne art scene is due not least to the work of public institutions. Their outstanding exhibitions and presentations of their own holdings can scarcely be overestimated in their importance. This is a notable achievement when one thinks how indecisive municipal authorities are by nature.

AUGUST SANDER

The present selection of photographs is drawn from an exhibition originally organised by the Cologne Stadtmuseum and brings together works by one of the classic figures in the history of the art of photography.

August Sander was born in Herdorf, a small town to the south of Siegen, on 17 November 1876. After leaving school he spent a number of years travelling around Europe, visiting, among other places, Berlin, Dresden, Magdeburg, Halle and Chemnitz, before settling in the Austrian town of Linz on the Danube. It was here, in 1901, that he and a colleague took over the Greif Studio. Two years later – by which time Sander had become the studio's sole proprietor – he was able to hold his first studio exhibition there. In 1904 came exhibitions and awards in Paris, Wels (Austria) and Leipzig.

After ten years of successful work in Linz, Sander sold up his business in the town and moved to Cologne. Almost immediately he began work on his first portraits. Taking in the whole of the Cologne region, they were to form the basis of his later portfolio *Man in the Twentieth Century*. Not until 1925, however, do we find Sander himself commenting on this and other portfolio plans. In a letter to the photographic historian Professor Erich Stenger of 21 July 1925 he writes, among other things, 'In order to obtain a proper cross-section of the present age and of our German nation, I have arranged these photographs in portfolios, beginning with the peasant and ending with representatives of the intellectual aristocracy. This line of development is contained within another portfolio, running parallel to the first, which shows the development from village to modern city. In this way… I hope to offer a true psychological portrait of our age and of our nation.'[1]

Sander's first contact with the *Gruppe progressiver künstler*, a group of artists based in Cologne, also dates from 1925. From the mid-twenties onwards he was a regular guest at the group's meetings, photographing the artists in Franz Wilhelm Seiwert's circle, including Heinrich Hoerle, Anton Räderscheidt and Gerd Arntz. But a whole series of artists' portraits would be unknown today if Sander had not captured them on film. (Many others were destroyed by the National Socialists, who regarded them as examples of 'degenerate art'.)

Of the various members of this group it was Seiwert with whom Sander had the closest contacts. They met frequently and talked at length about photographic work, new techniques and current trends in photographic composition.

In 1926 Sander joined the Cologne Photographers' Guild, a move which also enabled him to give his son Gunther a proper training as a photographer. At the same time, however, he had also become an important figure on Cologne's photographic scene. These years witnessed an increased interest in building up his portrait collection and in compiling a photographic record of Cologne's architectural history.[2]

The photographs which comprise his portfolio *Cologne as it was* (408 positives arranged in sixteen albums currently housed in the Köln Stadtmuseum) were all taken in the years around 1930. However, as the title of the collection makes clear, it was not until 1952, after the end of the Second World War, that Sander completed the portfolio and offered it for sale to the Cologne city fathers.

This visual record of the town and its history takes the viewer on a conducted tour, as it were, beginning with Cologne Cathedral and passing, via ecclesiastical and secular monuments, to the outer reaches of the city, essential historical details of individual buildings alternating with comprehensive aerial views.[3]

The different formats and types of shot that are found in the Cologne portfolios are evidence above all of the technical and stylistic variety of which Sander was capable.

Sander's decision to close his file on Cologne and offer it for sale was the result, first and foremost, of his own financial situation in the 1950s. In general his pictorial records were in only limited demand at this time. 'Stylistically, his portraiture could in any case not be appreciated for its true worth in the age of "subjective photography", while Sander remained a

August Sander was born in 1876 in Herdorf, Siegerland. He started taking photographs in 1892, industrial photography appealed to him in particular. After his miliatary service 1896-1898 he practised photography in many German towns eg. Berlin, Dresden, Magdeburg and Chemnitz. In 1902 he married in Trier and in 1903 he held his first exhibition in Linz. In 1904 he had two successful exhibitions, in Paris, in Wels, Austria and he won first prize in Leipzig. After further successes, in 1910 he bought a business and settled in Cologne, Germany and established a workshop there in 1914. Between 1914-18 he took part in the First World War, and on his return became a travelling photographer. During 1921 he met the progressive painters Seiwert and Hoerle, who had a striking influence on him and his work. In 1927 there was an exhibition in Cologne which was the first outcome of this work which received excellent criticism.

In 1934 some of his work was confiscated by the Gestapo and he was banned from a profession by the government between 1936-39. In 1944 he was forbidden to work in the Cologne workshop so he settled in a bakery in Westwald.

He began to exhibit again from 1951, and in 1955 he worked with Edward Steichen for the exhibition Family of Man *at the Museum of Modern Art, New York.*

During 1958 he became an honorary citizen of his home region Herdorf and received a number of important awards before his death in Cologne in April 1964.

Literature

August Sander, Köln wie es war, *ed. Rolf Sachesse with an introduction by Michael Euler-Schmidt, Köln 1988*

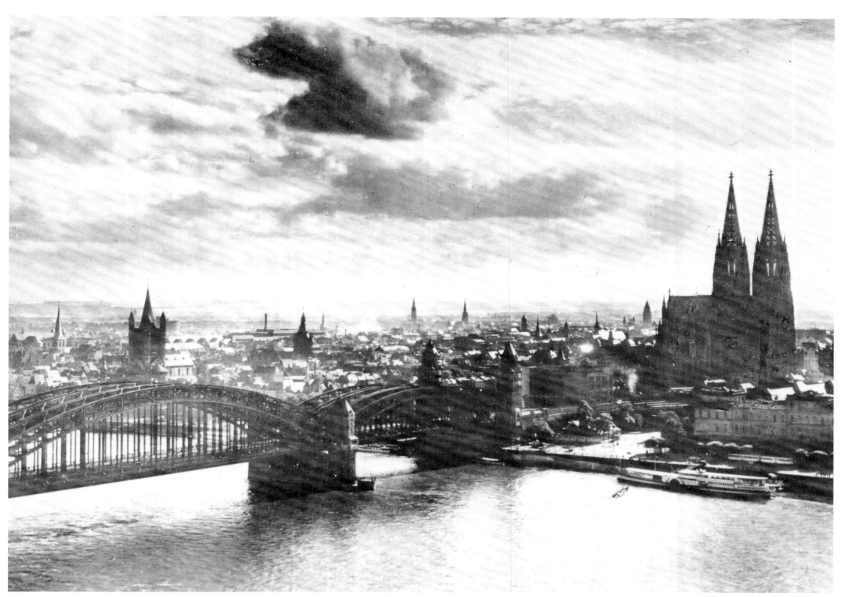

AUGUST SANDER
View from the Fair Building over Cologne

lifelong eclectic in matters of architectural photography, the object depicted always being of greater interest to him than the form in which it was depicted.[4] The response to Sander's Cologne portraits was correspondingly muted.

Only after his death in Cologne on 20 April 1964 was Sander to achieve classical status on the photographic scene, a status he owes not least to his work as a portraitist.

Dr Michael Euler-Schmidt

NOTES

1 Unpublished letter of 21 July 1925 from August Sander to Professor Dr Erich Stenger. Stenger's unpublished papers are lodged in the Agfa-Historama of the Wallraf-Richartz-Museum, itself part of the Ludwig Museum in Cologne.

2 August Sander, *Köln wie es war*, ed. Rolf Sachesse, with an introduction by Michael Euler-Schmidt (Cologne 1988), p.19.

3 op. cit., p.13.

4 op. cit., p.27.

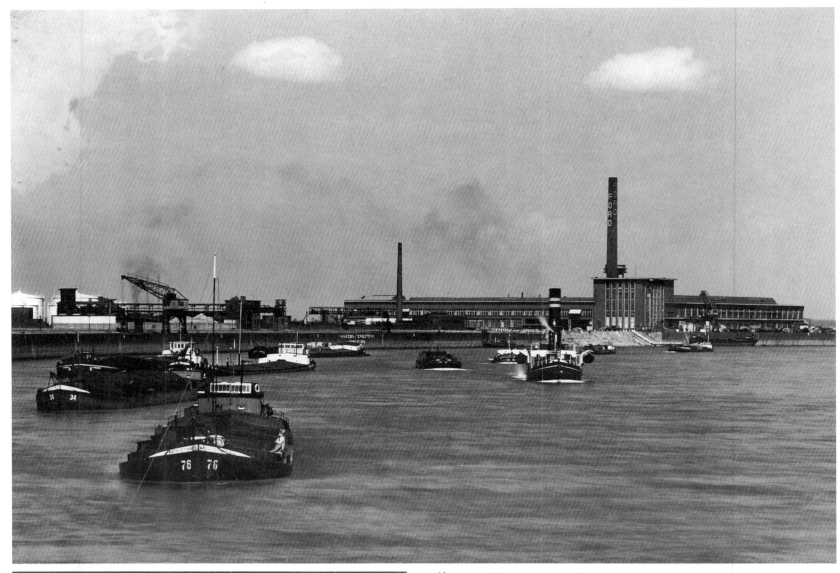

Above
AUGUST SANDER
The Ford Works 1932

Left
AUGUST SANDER
Untitled Carnival Portrait
(RBA 208885)

Opposite
AUGUST SANDER
Zeughausstrasse

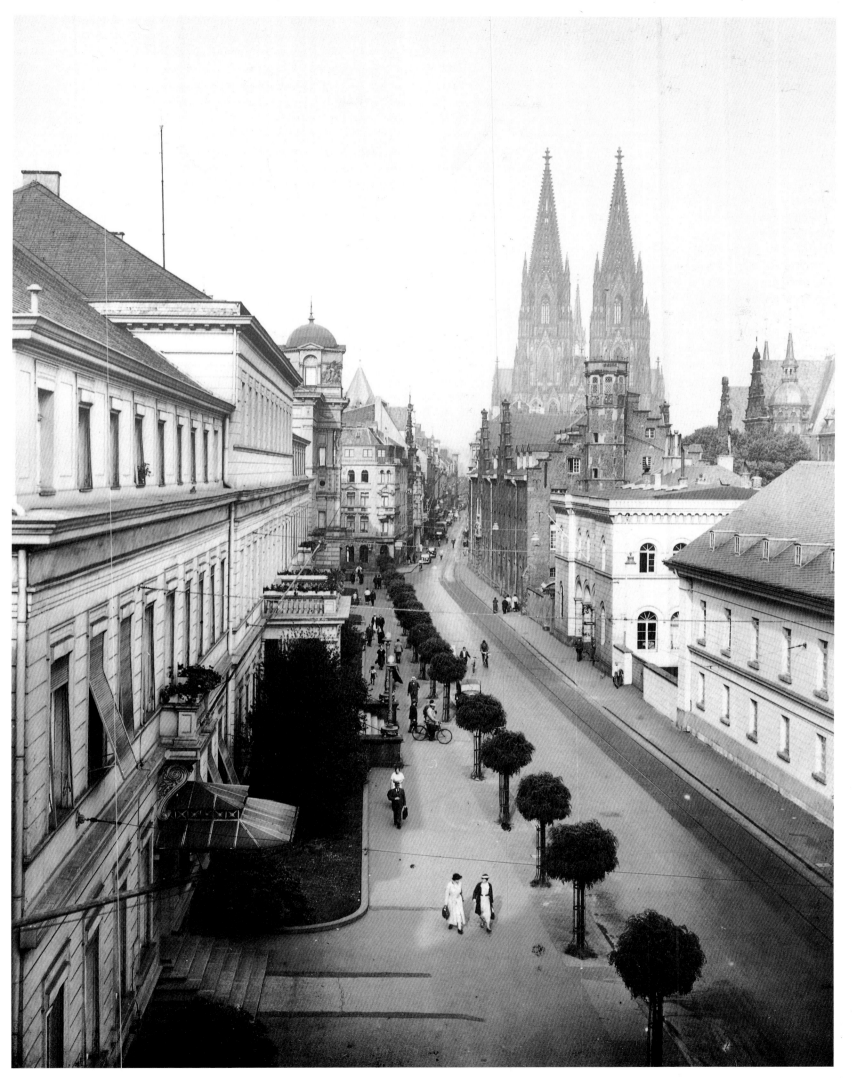

CHARGESHEIMER

Carl-Heinz Hargesheimer was born in Cologne in 1924. He spent six semesters studying graphics and photography at the Werkunstschule in Cologne, and began to make sculptures in metal in 1948. He first exhibited photographic work in 1950, and also edited one issue of Photo und Film Reporter *periodical in that year. From 1951-6 he taught at the School for Photography and Film 'Bikla' in Düsseldorf.*

From 1948-53 his photographic work was experimental, using solarisation techniques and extensive manipulation of the negative, but from 1953 his work moved entirely in the direction of photojournalism. From 1961-1967 his work centred on the theatre in cities as far flung as Hamburg and Vienna. In 1968 he returned to making three dimensional works in the form of kinetic sculptures. He died in 1972.

Major publications

1957
Cologne Intime

1958
Unter Krahnenbäumen, Im Ruhrgebeit

1960/61
Menschen am Rhein, Berlin. Bilder einer grossen stadt

1967
Theater Theater

1970
Köln 5 Uhr 30

Five statements. Five different opinions. It looks as though this is the most accurate way of expressing a view on Chargesheimer. Another half dozen characteristics could be added to the list and one would still be left with the impression that on each occasion it was a different person who was being discussed. Probably the only thing one can say about him with any certainty is that neither as man nor as artist can he be pigeon-holed, and that he does not really fit into any of the categories which the history of art and the history of photography have at their disposal. This is clear not least from the tremendous range of activities to which he devoted himself during barely twenty years of public life.

He began his photographic career by taking part in the special exhibition that was held in Neustadt in 1949 and organised by Professor Reisewitz to coincide with the Second International Exhibition of the Photographic and Cinema Industries. An immediate outcome of this exhibition (at which the young Otto Steinert was also represented) was the founding of the Fotoform Group, among whose wider achievements – that of 'Subjective Photography' – Chargesheimer's photographs are regularly reckoned. That he was represented at more or less the same time (1950) at an exhibition in Brühl by a wire sculpture offers early evidence of this versatile talent.

In 1958, having built up a reputation as a photographer and sculptor, he caught his public unawares with *Intimate Cologne*, following it up a year later with *Unter Krahnenbäumen*, two photoreportages which were immediately recognised as pioneering achievements and as influential in photojournalistic terms.[6] Reactions to Chargesheimer's book *In the Ruhr* were characterised by an extremism ranging from embittered protests to the highest praise.[7] In 1961 he revealed himself as an acutely perceptive portraitist not only with his portfolio of photographs of Louis Armstrong and Ella Fitzgerald but also with his book *Provisional Appraisal*. The 1960s were marked by his work as a set-designer and theatre producer (in Braunschweig, Kassel and Cologne), as a promotional photographer (for ROW and ESSO) and as a sculptor whose avowed intention it was to replace the African hemp that grows in every German living room with what he himself called his 'Meditation Mills' or kinetic sculptures.[8] Finally, in 1970, his book *Cologne at 5.30* gave evidence of his increasingly pessimistic view of civilisation and his sense of bitterness at the growing fragmentation of human life.

Only contradictions seem to do justice to Chargesheimer's images. Like his French colleague Henri Cartier-Bresson, he is always on the look-out for the *moment décisif*, but the moment in question is the opposite of the one that Cartier-Bresson fixes. Whenever Chargesheimer pressed his shutter release, what he captured on film was something no one expected: what he

wanted to show in his pictures was not what people say, not how they saw themselves, but how they really were. Fascinated as he was by the theatre, Chargesheimer saw in people's social behaviour only so many examples of role-playing, and so he waited until the people whom he observed and with whom he lived and socialised stepped outside their roles and became their true selves. 'What we see within the narrow confines of *Unter Krahnenbäumen* is an even more intimate version of *Intimate Cologne* than emerged from Chargesheimer's 1957 volume of photographs, a volume as original in its text as it was in its images. Only someone acquainted with Cologne or who has lived there all his life will be able to appreciate fully the atmospheric authenticity of these photographs,' Karlheinz Wallraf wrote in 1958 in the periodical *Bücherei und Bildung*.[9] As a picture caption he explained, 'Having once leafed through the book, you are tempted to set off at once and visit Unter Krahnenbäumen to see what you have just been looking at. But, of course, you would not find it there. A single glance would not be enough to reveal the street to you... Chargesheimer never penetrates behind the walls of the houses in their street. He simply strolls along it and captures its very heart. For this street comes to life, thanks to him'.[10] The redevelopment of the town has in any case meant that such a stroll would no longer be possible today. But even Chargesheimer's contemporaries failed to see what he showed them. What he revealed here was not so much typical of Cologne as of an everyday existence which would probably never have become familiar to anyone outside the circle of those people who lived that life if Chargesheimer had not showed it to us. Chargesheimer's Cologne is the axis around which his world revolves. Five of his photography books deal with his hometown and with the people who live there: *Intimate Cologne*, showing familiar and unfamiliar sides of Cologne; *Unter Krahnenbäumen*, with its scenes of small-town life in one of Cologne's back streets; *Cologne at 5.30*, portraying the town as a housing, transport and communications system; *People on the Rhine*, about people living, working, relaxing and travelling on the River Rhine; and *Romanesque Rhine*, with its scenes of thriving medieval life and of medieval ruins.

If Cologne and the Rhineland can be described as the focal point of Chargesheimer's creative work, it was the theatre around which his thinking revolved. Whereas his photographs of Cologne were a means of exposing the everyday world as a world of appearances and role-playing and as a way of distilling its essential, human core, the theatre offered him a chance to study every aspect of appearance, of pathos, mime, gesture, costume and scenery. In life even the carnival season with its wild goings-on offered imperfect protection against the wearisome labour of human existence. The theatre by contrast remains within the framework of its make-believe reality. Experimentation and playful dealings with people and things offered their own attraction, exerting an appeal to which Chargesheimer gave himself up for six years as a set-designer and producer and also, of course, as a photographer. For Chargesheimer, the theatre was the one place where reality was intensified to the point where it became pure form, a place whose reality was in need of constant revision. Just as the reality of the theatre interested him, so he was fascinated by the human being within the actor, photographing him not only on stage, in the wings and in the theatre canteen but also outside his field of professional activity, without make-up or costume. Back in the studio he focused his photoflood on the faces of his colleagues from the theatre, seeking to discover what they were hiding from him on stage when playing their theatrical roles. That is why his exceptional portrait photographs from this period caused such a sensation. His flashlight was pitiless in lighting up the person's face: his sitters were entirely at Chargesheimer's mercy. During the course of an interview with him in 1957, Daniel Masclet submitted to this process: 'What a technique! He's clearly got a talent for mastering technique! Judge for yourself: in his right hand, pressed against himself, he holds his Reflex; in his left hand he balances his electronic flash, he stuck a Proxar lens over the lens, only 60 centimetres away from my nose... As for the flash, it is no

further away from me; and Chargesheimer points it in every direction – upwards, downwards, forwards to the side... This technique reminds me of the lamp guns that were sometimes used on film sets.[11]

No less than his photographs of Cologne, Berlin, the Ruhr and the theatre, Chargesheimer's portraits bear witness to his search for what lies hidden beneath the surface. 'Once you have seen these representations, you will always see the people portrayed in exactly the same way, even if they look different in other photographs.'[12] Not a few writers on Chargesheimer regard his portraits as his real achievement and as his particular contribution to the history of photography. The role of Chargesheimer's photographic work is orientated towards people and even in those photographs where people are nowhere to be seen, as in *Cologne at 5.30*, his concern is with the life-denying insensitivity of urban planning. For the Cologne of the 1960s Chargesheimer was a cult figure. His photographic work is one of the milestones in the recent history of photography.

Reinhold Misselbeck

NOTES

1 Daniel Masclet, 'Die Photographie im Ausland: Chargesheimer in Köln', *Photo Cinema* (October 1957), p. 245.

2 Karl Pawek, 'Chargesheimer', *Zwischenbilanz* (Cologne 1961), p. Xi.

3 Hans Schmitt-Rost, 'Über Chargesheimer', *Cologne intime* (Cologne 1957).

4 L Fritz Gruber, 'Chargesheimer', *Grosse Phlotographen unseres Jahrhunderts* (Berlin/Darmstadt/Vienna 1954), p. 192.

5 Chargesheimer', *The British Journal of Photographers Annual* (London 1964), p. 177

6 See for example Theo Thiebold, 'Ein Buch, das Köln auf den Grund geht: Chargesheimer und Schmitt-Rost, "Cologne intime"', *Kölner Stadt-Anzeiger*, No 279.

7 '"So grau ist es bei uns nicht": Das Ruhrgebeit wehrt sich gegen ein Bildbuch', *Hamburger Abendblatt*, No 294 (18 December 1958), p. 11.

8 Werner Schulze-Reimpell, 'Glasmachine als Gegenwelt: Chargesheimer hat der Zimmerlinde den kampt angesagt', *Die Welt*, No 227 (27 November 1968), p. 11.

9 Karlheinz Wallraf, reveiw of *Unter Krahnenbäumen* in *Bücherei und Bildung*, 11 (1959), 380.

10 loc. cit.

11 Daniel Masclet (note 1), p. 244.

12 Karl Zimmermand, 'Photographic Busts by Chargesheimer'. *Photorama*, 7 (February 1957), 243.

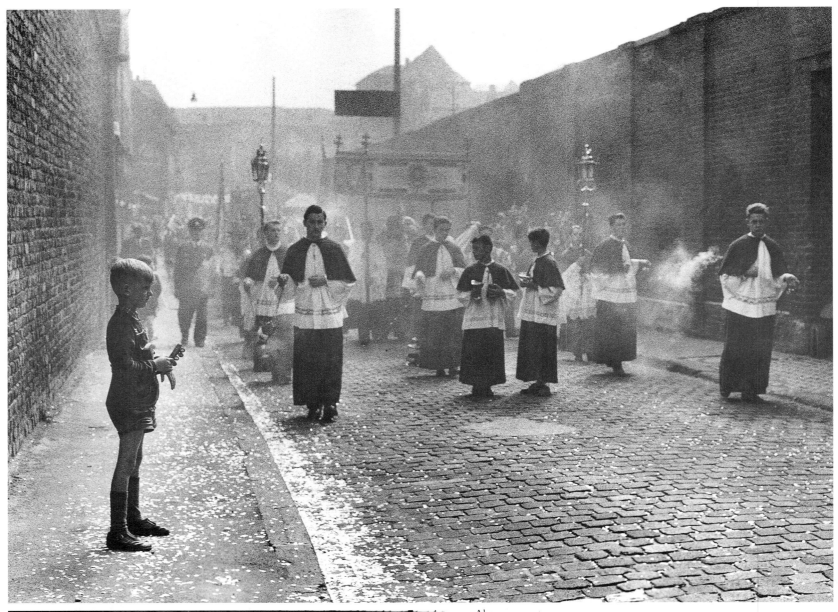

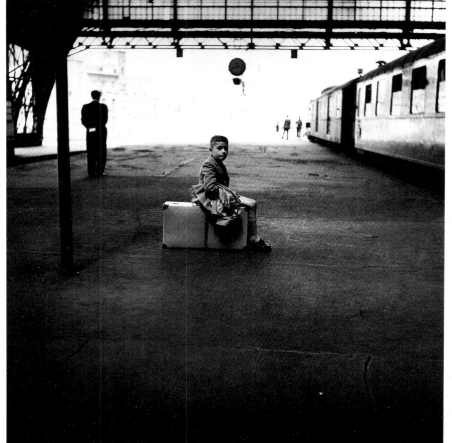

Above
CHARGESHEIMER
Unter Krahnenbäumen Procession

Left
CHARGESHEIMER
Railway platform, Cologne

Opposite
CHARGESHEIMER
Unter Krahnenbäumen-Stüffge 1957

Cover
CHARGESHEIMER
View of the Cathedral 1957

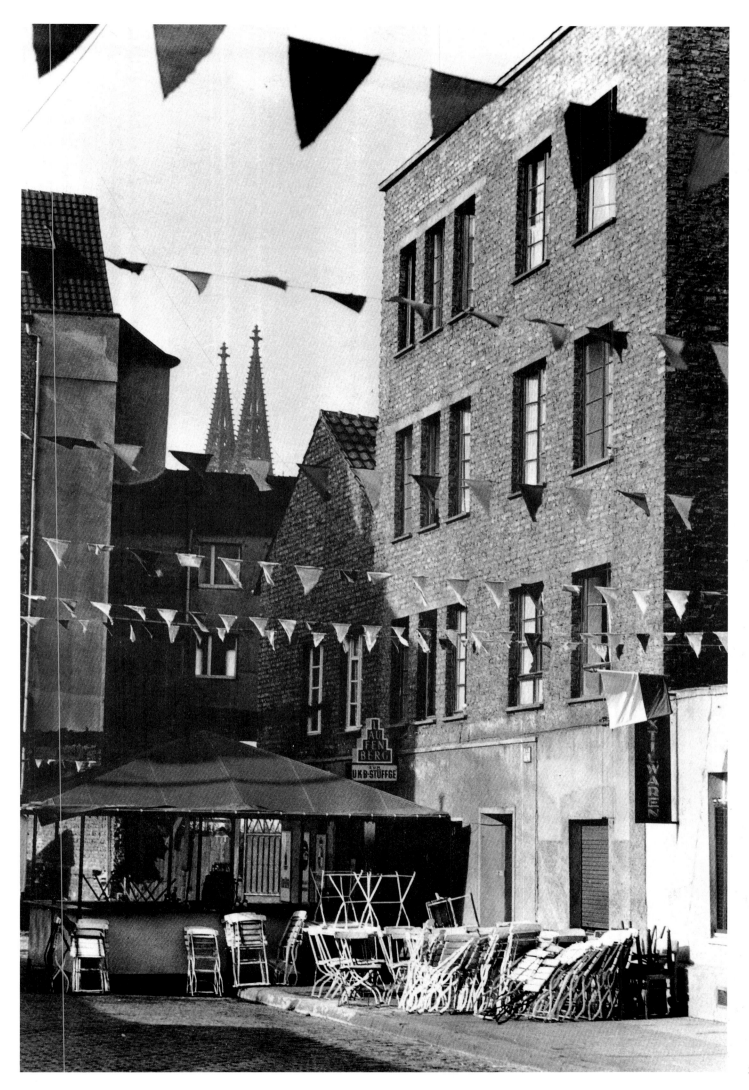

GERHARD RICHTER

Gerhard Richter was born in Dresden in 1932. He began work as a set painter and advertising designer, and went on to study at the Dresden Hochschule für Bildende Künste, graduating to the master class which he left in 1960. He then moved to Düsseldorf where he studied under K O Götz. In this period he moved away from straight figurative painting, and began to work with images from the media, playing with the nature of perception and realism. His work was briefly misconstrued as being allied to Pop Art, although it took a critical position and his use of popular imagery has always had a more painterly intent. He taught in Hamburg and then, after 1967, in Düsseldorf, where since 1971 he has taught at the Staatlichen Kunstakademie. He has lived in Cologne since 1983.

Recent one person exhibitions include

1986
Düsseldorf, Kunsthalle, Retrospective
Wien, Museum des 20 Jahrhunderts
West Berlin, Nationalgalerie, Stiftung Preussicher Kulturbesitz

1987
Amsterdam, Museum Overholland
New York, Marian Goodman
New York, Sperone Westwater

1988
Toronto, Art Gallery of Ontario

Literature

The Düsseldorf exhibition was accompanied by a book, as was that at Toronto, which has appeared under the Thames and Hudson imprint, Terry Neff, ed, Gerhard Richter Paintings, London, 1988
Ulrich Loock and Denys Zacharopoulos, Gerhard Richter, München, 1985

Richter's reversals, his subversive approach to established traditions, are aimed at discovering the possibility of a new unknown order; and the uncharted space he is attempting to carve out for abstract painting is not mystical, despite its elusiveness. It results from a powerfully directed critique of the work in hand, together with a free-ranging experimental attitude to the possibilities of his medium, which is essentially affirmative in spirit and directed towards the future.

This new mood of critical affirmation has its roots in disillusion, in Richter's deepseated distrust of the ideological alternatives of post-war painting, which had been codified during the cold war years in divided Germany into rigid opposition of socialist realism *versus* abstraction. Born in Dresden in 1932, Richter moved to the West in 1961 (following five years at the Dresden Academy), and enrolled in K O Götz's class in Düsseldorf, where he studied until 1963. At this historical juncture the formalist rhetoric of West German *Informel* – like the banal illustrations of socialist realism – were viewed increasingly as empty formulae by young artists of Richter's generation. In 1961 Joseph Beuys was appointed professor at the Düsseldorf Academy, and a new context for experimentation emerged with Beuys' open studio and the impact of Fluxus events in the Rhineland. The critical trajectory of Fluxus and neo-dada in the sixties, the moods and concerns associated with these movements, have had a lasting impact on Richter's art. His continuing interest in experimental music,[1] his exploration of 'controlled chance', the strategies he uses to displace subjectivity – above all his Duchampian ambition to create art that is *intelligent* – all bears witness to his roots in neo-dada.

But there is one crucial difference: the neo-avantgardism of the 1960s was committed to a 'revolutionary identification of art and life' – and it is for this very reason that its project is usually deemed to have failed.[2] Renewing the avant-gardists' attack on the barriers between art and life in the consumer society of the post-war world did little more than open the floodgates of appropriation. The strategies that Gerhard Richter evolved to express his insistence on difference and displacement when it came to the relations between life and art marked him out from mainstream neo-avantgardism and testified to a new seriousness of intent.[3] This did not involve him in a retreat into modernist isolation, but rather in an attempt to steer an alternative course, one that took account of the complex issues of non-identical interrelation between art and life. The history of Richter's painting over the next two decades relates to his attempts to regain a critical distance, to interpose a difference that resisted the dominance of consumption.

If art and life were not to be reduced to a single unproblematic identity, photography provided Richter with a means of engaging with the issues this raised. Relating to both categories, photographs can be used to reveal or to conceal – but never to resolve – the paradoxical interface between life and art. By making paintings that aspired to the state of photography, ('*I do not wish to imitate a photograph; I want to make one...I am making photos with different means and not pictures which resemble a photograph*'),[4] Richter set out to explore this realm, in which codes cross and yet retain separate identities; the photograph could be used to draw our attention to issues of visual appropriation. In the sixties Richter favoured black and white amateur snapshots; he also used news photos and travel shots which give us the illusion of coming close to distant events and places. But despite the familiarity of these images, his paintings do not confirm a sense of visual understanding and resultant knowledge. Instead they disorientate and throw into question unquestioning habits of viewing: the representation of cliché makes us aware of emptiness, the isolation of visual fragments makes us admit the incompleteness of knowledge, the blurring and slipping of the image (affected by running a dry brush across the surface of the paint) demonstrates the fissure between illusion and reality. The photo-paintings provoke an awareness of our everyday unconscious acts of visual appropriation – and by doing so they resist appropriation themselves.

Richter's photo-paintings of the 1980s engage with related issues, questioning accepted modes of identifying visual perception with emotive response. Richter never works directly from nature – at most he photographs it, and these colour photographs of landscapes, mountainscapes, or urban scenes are first projected onto a white primed canvas and roughly sketched in pencil. The colour print is then laboriously copied in oil with a fine brush. On the one hand colour intensifies the illusion of reality, but on another level these works paraphrase inherited modes of landscape painting, recalling Caspar David Friedrich or Corot; they also relate to conventions of photo-advertising. The smooth surfaces and romantic views are seductive and inviting, but there are also various strategies of closure in the paintings which make us pull up short. Frequently the landscape views are empty and distant, alternatively our view is blocked by a ridge of trees or a gate. There is an even, uneventful distribution of light, and nature is windless and still. Paths and gates lead nowhere in particular, and despite the romantic associations there is a peculiar mood of emotional neutrality, of aimlessness, that pervades the scenes. From a certain distance, the rhythms of brushwork in the foreground of *Beech Tree* are visible, but when we approach the canvas the fine touch of the artist's hand disappears from sight. In *Marcay* this kind of visual disorientation recurs on a more general level in the images as a whole, as physical proximity does not guarantee increased clarity of perception. On the contrary, the close-up is less precise than the distant view and our attempt at visual approach is confounded by the dissolving and diffusion of the image, like an over enlarged photographic detail. It is as if we are never allowed to stand at quite the right imaginative distance for our visual and emotive responses to concur; attempts to grasp, to understand are frustrated.

There is no doubt that the abstract works are the most important aspect of Richter's painting in the eighties, ('*the abstract works are my presence, my reality, my problems, my difficulties and contradictions*'[5]), and the landscapes are painted during necessary pauses and intervals when he steps back from his *alla prima* painting to regain critical distance.

Richter began his abstract work – first small and medium sized oil sketches – in 1976 in reaction to the reductive minimalism of his grey paintings which were shown at the exhibition *Fundamental Painting* in Amsterdam in 1975. Alongside his exploration of the elusive interface between art and life in the photo-paintings, Richter was also preoccupied with testing out the limits and potentials of art – very much in the spirit of 1970s conceptualism, although he remained primarily concerned with the possibilities of painting as a traditional yet transformable medium. He has described the grey paintings as, 'the most complete ones I could imagine…the welcome and only correspondence to indifference, to a lack of conviction, the negation of commitment, anomie. After the grey paintings, after the dogma of "Fundamental Painting" whose purist-moralizing aspects fascinated me to a degree bordering on self-denial, all I could do was to start all over again. This was the beginning of the first colour sketches conceived in complete openness and uncertainty under the premise of "multi-chromatic and complicated," which obviously meant the opposite of anti-paintings and of painting that doubts its proper legitimacy.'

Again and again in his diary notes he stresses the importance of beginning without any aim or direction, of remaining fully open during the process and avoiding any preconceived notion of result: '*therefore the act of painting is a semi-blind, desperate attempt – like someone without means set down in a quite familiar environment, who possesses a variety of tools, materials and abilities and who has an urgent desire to create something meaningful, useful. But this must not be a house or a stool nor anything else we can name, so he just has to start building in the vague hope that his honest competent work will eventually produce something right, something meaningful*'[6]

Jill Lloyd

GERHARD RICHTER
Elizabeth I 1966

NOTES

1 John Cage still plays an important role; experimental music after Cage is of less interest to Richter.

2 Peter Bürger *Theory of the Avant-Garde*, Manchester 1984 p. 616

3 For a history of Fluxus in the Rhineland see Johannes Meinhardt, 'Fluxus and Paupstron; Die Ausbildung einer Sprache der Aktion bei Beuys' in *Brennpunkt Düsseldorf*, exhibition cat, Kunstmuseum Düsseldorf 1987. Meinhardt describes how Beuys too, via a new style of performance, detached himself from mainstream Fluxus

4 *Gerhard Richter*, exhib. cat. 36 Venice Biennale, 1972 p. 23

5 Interview with Dorothea Dietrich, *The Print Collector's Newsletter*, vol XVI no 4 Sept-Oct 1985 p. 128

6 Museum Overholland Amsterdam op. cit. p. 8 (28.2.1985)

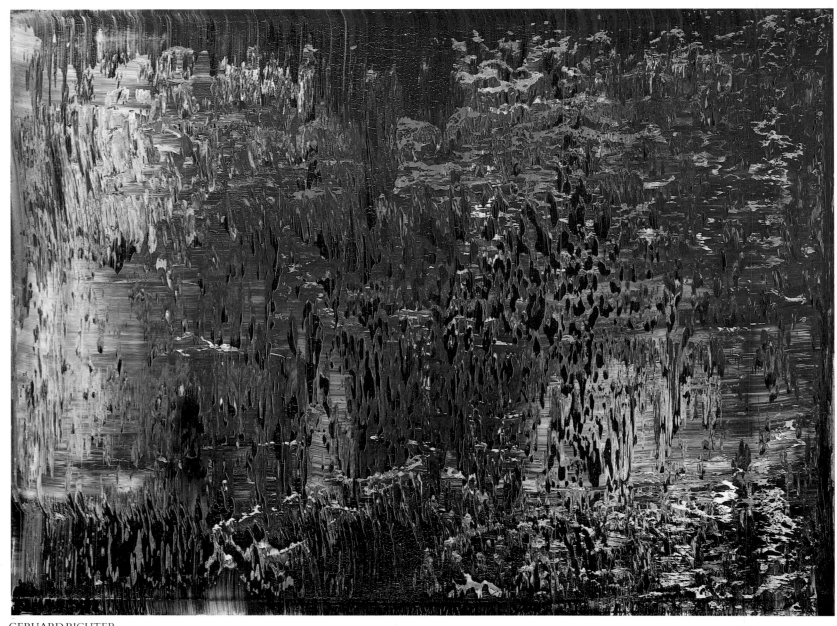

GERHARD RICHTER
St John 1988

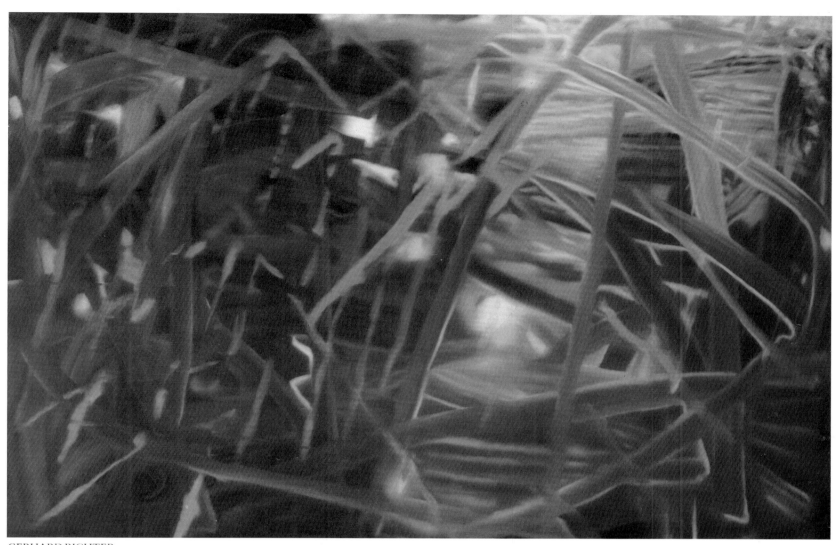

GERHARD RICHTER
Abstract Painting No. 439 1978

SIGMAR POLKE

Sigmar Polke was born in 1941 in Oels, Silesia, and moved to the area of Mönchengladbach in 1953. After an apprenticeship in glass painting, he studied at the Academy in Düsseldorf under K O Götz and Gerhard Hoehme. His first solo exhibition was in 1966 in Berlin. In 1963, along with Richter and Konrad Fischer-Lueg, Polke announced the birth of 'Capitalist Realism', with an exhibition in a large furniture store in Düsseldorf. In 1964 Polke began to use news-photographs by silk screening enlarged versions onto canvas. He also transferred the most everyday objects onto his canvas, raising kitsch to a high-art context and setting it off against abstraction. At the same time he worked on other paintings in which he partially obscured the image by over-drawing. Polke was made Professor at Hamburg Academy of Art in 1977. He now lives in Cologne.

Recent one-person exhibitions include

1984
Köln, Josef-Haubrich-Kunsthalle

1988
Bonn, Kunstmuseum, Sigmar Polke: Zeichnungen, Aquarelle, Skizzenbücher
1962-1988

1988/9
Paris, ARC

Literature

The above three exhibitions were accompanied by catalogues.

The pursuit of unintelligibility is not an easy practice, for it is hard to shed intelligibility, especially after centuries of struggling to achieve it. Polke carries this pursuit to a new reckless gnostic extreme. In Duchamp the assignment of artistic value to the readymade mocked the game of art without abolishing it. It mocked but did not deny the institutional definition of art. And it created a new naîveté, broadening the boundaries of the institution of art to include whatever anyone who declares himself to be an artist declares to be art, that is, to include the mad.[1] In Polke something both more nihilistic and more subtle occurs: art's ability to convey unspeakable, unintelligible 'depth' is put to the test, putting it in the position of doing away with itself if it succeeds. If art is really able to be inarticulate, it is not art; it is suicidal for it to pursue the unintelligible. And yet, as we will see, it is the only way to save itself from its own always immanent banality and the banality of the world. Art that is truly art is always in this double bind for Polke.

Polke's art can be described as 'schizophrenic' in the postmodernist sense that has been attributed to that appropriated term,[2] but this is to misunderstand it, as well as the import of the so-called schizophrenic. To allude to the Adorno epigraph, Polke's art demonstrates the necessity of unintelligibility to art. His best works show unintelligibility in action. Art historically understood, his 'proof' of the necessity of unintelligibility signals the final throwing off of the shackles of purity. Purity now reveals itself as repression of the expressive depth signified by enigmatic unintelligibility.

Polke creates the sense of unintelligibility through the extreme suggestiveness of his works. It is a suggestiveness which initially appears through the dizzying multiplicity and overlapping of systems of style and meaning – a pictorial situation in which it is impossible to give one meaning priority over another, which is why it has been called schizophrenic. There is a kind of free play of systems, in both imagistic and gestural signifiers. This playfulness tends to destroy differentiation – a tendency towards the undifferentiated that is particularly strong in Polke's completely gestural works, with their figures of 'free speech'.[3] But even the capitalist realist works (1963 onwards) show the same drift towards undifferentiation, partly through their integration of image and gesture.

The typical Polke picture, then, gambles with visual meaning variables with no sense of what might be won – what kind of determinate relationship between them can be created. A kind of joke is played on pictorialness as such, or rather, pictorialness itself becomes a joke. It is impossible to determine whether the nominal picture is a mediation of the world or an 'immediation' of visual variables. It does not matter which it is, because it is neither. Polke creates a pictorial situation of extreme equivocation, where evocation is everything, but nothing is clearly evoked. There is no final, known picture. No hierarchy of forms is established, so that connotation rambles. The joke of the typical Polke picture is that every element in it cancels every other element's attempt to dominate the scene – be the pictured thing.

The major moment in Polke's development occurred when he stopped making capitalist realist works and began making those that 'higher beings' commanded him to make. This happened in 1966, with the Vitrinenstück, in which the higher beings commanded Polke to paint flamingos when he wanted to paint a bunch of flowers. They clearly meant business, as he remarked, for they would not let him do what he wanted to: they took over his will. For all their seriousness and determination, the higher beings did allow Polke to continue making lighthearted works in a capitalist realist vein. With their help, he was able to 'spiritualize' the objects he was rendering by 'abstract' – 'higher' – handling. They began to look more improvised, less inevitably banal, more like sublime, suggestive screen memories, than ever. The higher beings really confirmed, and gave a vigorous push forward to, the 'alchemical' tendencies already evident in the capitalist realist works.

For all its tongue-in-cheek character, Polke's escapist exoticism is a

basic weapon against the increasingly encroaching forces of banalisation. They work through – their pathological character manifests itself decisively in – what Breton called 'miserabilism': 'the depreciation of reality in place of its exaltation'.[4] The beings who command Polke are higher because they have the power to exalt reality, which is what fantasy does, in contrast to modernity's inevitable depreciation or banalisation of it. This is why the pictures made at the command of the higher beings have an idealistic aura, however ironically.

Donald Kuspit

NOTES

1 By encouraging everybody to become an artist by 'choosing' an object as a work of art, Duchamp is in effect encouraging them to act mad. He plays upon the conventional idea of the artist as madman, a sort of socialized madman. More particularly, the concept of everyman-as-artist by way of the readymade unites the grandiosity of the madman's 'I am both Napoleon and Christ' with the self-deception embodied in the 'emperor's new clothing' idea. The emperor, of course, is always divinely, arrogantly right. These two principles of mad art-making guaranteed to make mad art as well as to certify the artist's madness signify the narcissistic over-estimation of the self. Polke's own version of the artist-as-madman derives from Nietzsche's delusionary overestimation of himself – the explicit sign of his psychosis – as Dionysus and Caesar in one. But Polke, more hopefully, tries to use the Dionysus in himself to defeat the Caesar.

2 The argument for postmodernist schizophrenia is presented at its most concentrated in Frederic Jameson, 'Postmodernism and Consumer Society', *The Anti-Aesthetic*, ed. Hal Foster (Port Townsend, Wa., Bay Press, 1983), pp.118-22, and even more succinctly in Jean Baudrillard, 'The Ecstasy of Communication', ibid., pp.132-33. It ultimately derives from Gilles Deleuze and Feliz Guattari, *Anti-Oedipus, Capitalism and Schizophrenia* (1972; Minneapolis, University of Minnesota Press, 1983). From a psychiatric point of view, it involves a preposterous misunderstanding and misappropriation of the concept of schizophrenic pathology – a facile application of it to advanced capitalist society.

3 As Dirck Stemmler points out in his essay for the Museum Boymans-van Beuningen exhibition of Polke's work in 1983, 'Since the early 1970's Polke's interest has increasingly focused on the properties of paints, solvents and binders, … on new painting, casting and 'welding' techniques and on 'faults', chemical changes and destructive factors which he uses productively. In sketch-pads and on single sheets of paper he studies similar effects using inks and washes together with water-soluble opaque paint' (p. 42). Gaston Bachelard, in *The Psychoanalysis of Fire* (Boston, Beacon Press, 1964), regards alchemy as a fantasy of rejuvenation, tying it to mental breakdown. He also says it is traditionally practised by isolated bachelors, and can be understood as their masturbatory activity. Polke's alchemistry involves the practice of Dionysian unintelligibility to regenerate the charisma of art.

4. André Breton, 'Against Miserabilism', Surrealism and Painting (New York, Harper & Row, 1972; Icon Editions), p.348.

SIGMAR POLKE
The Dream of Menelaus I 1982

SIGMAR POLKE
Cattle and sheep go together
(Dream of Menelaus II) 1982

ULRIKE ROSENBACH

Ulrike Rosenbach's development as a performance artist (she herself speaks of 'action/performance') falls into three periods and shows a growing interest in those questions which are raised for her by her everyday experiences as a woman. Her interest has not developed in any methodical way, rather has her field of experience – in other words, everything that affects her and everything that she sees as problematical in her daily praxis – gradually expanded in scope as a result of her rigorous preoccupation with questions that affect the way in which she sees herself. In this way she has learned to deal in wider contexts and so transcend the limitations inherent in every well-defined and self-contained classification or dispensation.

Her starting-point is the question, what is the female self? What does it mean to be a woman? What lies hidden beneath the confusion of roles, cliché and models that constitute our view of women? How can women express themselves creatively? And how can women – who still see themselves as subject to external controls and impositions – achieve self-determination?

During the early 1970's Ulrike Rosenbach began to examine the stereotyped images which she discovered not only in others but also in herself, and to question all that happened to her in terms of her own self: a complex mixture of historical, sociological and individual images of women which she felt to be alienating and a form of self-expropriation but also as the essential basis of her subjectivity. Madonna, Amazon, Venus and Medusa are the imaginary models with which some women identify, models on which women are just as fixated as men and which condition the way women view themselves socially. From this follows the crucial question: what would emerge if all these historical layers of disparate images were stripped away? What would one discover at the beginning of history as the essence and substance of female nature? What is the one original, genuine element in these endless historical superimpositions and overlapping images? These are questions which Ulrike Rosenbach asks above all with the help of a video camera which she uses in her 'performances', superimposing historical images on herself on the video screen, relating the whole spectrum of stereotyped models and clichés to her own situation and testing their validity by applying them to herself. She uses a video camera to transform herself into an image for her own benefit, observing herself on the monitor and seeking to get to the heart of what she sees there. By attaching the camera to her body, she is able to obtain extreme angles of vision and extreme views not only of herself but of whatever the camera is pointed at. Video serves here to duplicate her own angle of vision in terms of real time: a view of herself as of an image, a phantasmagorical presence, to which the collective, cliché-ridden view from outside (a view which thinks only in terms of conventional models) is exposed, thus revealing the dividing line between heteronomy and self-discovery.

During the second half of the 1970s Ulrike Rosenbach began looking for answers to the question, what a 'woman' actually is. It was a search which involved investigating primitive societies, matriarchal cultures, the early cult of the Great Mother and matriarchy in general. A new world was opened up to her, a lost world, forcibly repressed, in which nature and society were still as one, since power did not yet exist as brute force and suppression: Mother Nature still lived and gave birth in harmony with human mothers, and rationality was not yet divorced from the life of the body and soul. It was a world, in short, of deep and magical associations, of a ritual, mythical knowledge which did not seek to rise above its immersion in physical nature and which expressed itself in grand and simple symbols. Ulrike Rosenbach works with these symbols in her performances, their unfathomable and effective significance communicating itself directly on an intuitive level and striking an echo in those layers of the soul that are affected by it (for everything corresponds with everything else in Mother Nature). The performance becomes ritualised, a real and, at the same time, surreal establishment of relationships, experiences of a transcendancy which is

Ulrike Rosenbach was born in Bad Salzdetfurth in 1943. She studied at the Staatlichen Kunstakademie Düsseldorf from 1964–9, and began to make video works in 1972. In 1976 she founded the 'School for Creative Feminism'. In 1983 she was guest professor at the Performance Class of the West Berlin Hochschule der Künste, and in 1984 at that of the Staatliche Akademie der Bildenden Künste, Münster Division. From 1986 she has taught at the Fachochschule für Kunst und Design. She lives and works in Cologne. From 1978 she has presented performances and installations, from 1980 solo shows, and from 1982 has been increasingly involved in video presentations. In 1983 she made a lecture and performance tour in Canada and the USA. Her first video work was 'My Transformation is my Release' 1978. Since then she has made around twenty video works, including '1000 Kisses' of 1983, a collaboration with Klaus vom Bruch.

Recent one person exhibitions include

1986
Düsseldorf, Galerie Meier-Hahn

1986
Aachen, Sammlung Ludwig, Neue Galerie

1987
Basel, Galerie Stampa

She has recently participated in the following

1987
Bonn, Kunstverein, 'Wechselströme'
Düsseldorf, Kunstmuseum, 'Brennpunkt Düsseldorf'
Kassel, Documenta 8
Bonn, Frauenmuseum, 'Self'

Literature

The above group shows were accompanied by catalogues, as was the 1986 Aachen solo show.

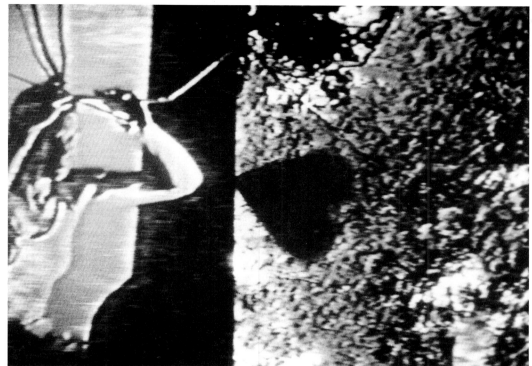

ULRIKE ROSENBACH
Sound of the Lotus Budding 1979 (video stills)

ULRIKE ROSENBACH
Dream-Wind 1988 (video still)

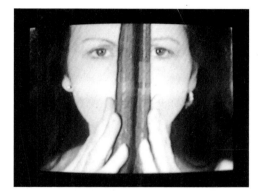

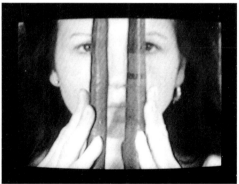

ULRIKE ROSENBACH
Psyche-Aber 1981 (video stills)

not, however, conceived of in Dionysian terms but rather as something meditative; it is strictly composed, far removed from all gesticulatory or theatrical excesses: what is expressed is less a sense of physicality or gesture than the immanence of what is felt and sensed to be the meaning of the symbolic action. (For this reason, Ulrike Rosenbach's performances can rarely be repeated: the intensity they require must be recreated on each new occasion.) The video camera now serves first and foremost as a means of representation, reproducing the situation for all its participants and providing a kind of psychic feedback of that situation (a situation which can be enacted in normal spaces and using normal light, since no suggestion of theatricality is intended here).

During the 1980s this field has once again been widened in scope: Ulrike Rosenbach recognises that primitive utopias cannot provide an answer to the problems felt by the women of today, and that the question as to the essential nature of women inevitably involves a more general context. She has begun to move towards a universal spiritualism, a spiritualism which thinks in cosmic terms, drawing extensively on Renaissance sources such as the microcosm/macrocosm analogy and the universal system of analogies, and interpreting 'male' and 'female' merely as spiritual polarities, so that the spirituality may itself be represented androgynously. (Attempts by alchemists to produce the androgyne by fusing together opposites are taken up again here.) But, above all, this new, cosmic spiritualism thinks in ecological terms; the concept of ecology is extended to cover the most remarkable elements. A whole world of theoretical practices, important to classical antiquity and embracing an 'ecology' of the body, of social life and of the psyche (including gymnastics, diet and every kind of 'self-concern', such as concern for the given physical, economical, sociological and political individual), is now taken up again on a spiritual level: the result is a kind of spiritual ecology expressed as a concern for the cosmos, spiritual wholeness, the world as the world in which we live.

Johannes Meinhardt

33

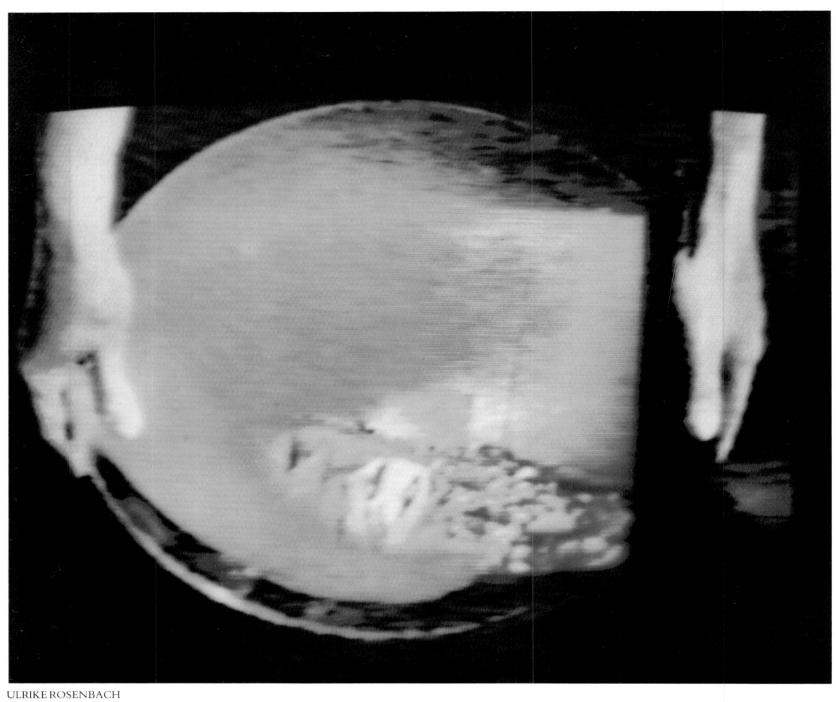

ULRIKE ROSENBACH
Dasteenband – Visual Gong 1983 (video still)

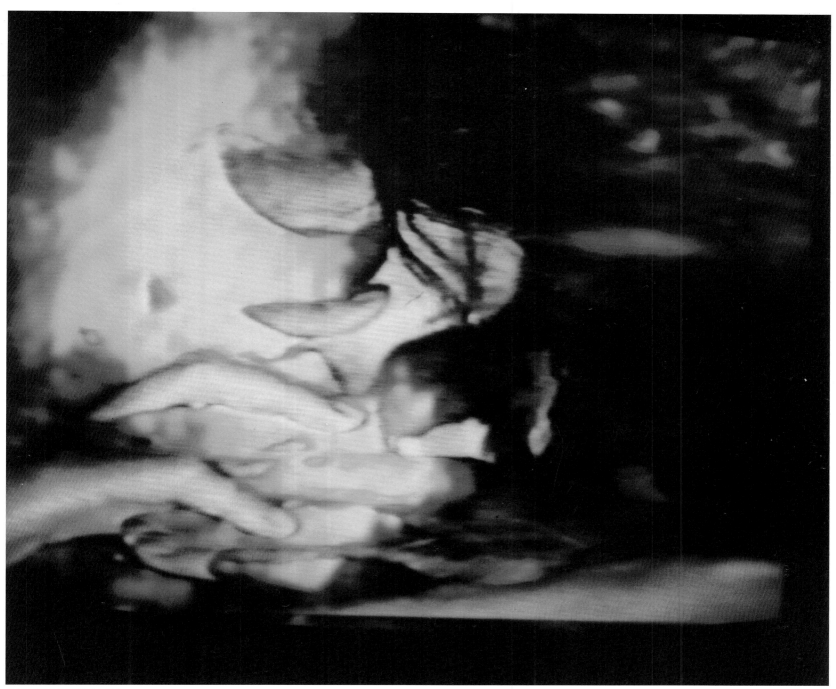

ULRIKE ROSENBACH
Eleven – Understanding is like heat 1985 (video still)

CHRISTA NÄHER

Christa Näher was born in 1947 in Lindau. She now lives in Cologne. Her work has roots in the Romantic tradition, with a sense of deep space. These spaces suggest urban or rural vistas, peopled with dreamlike or mythical animals and people. A number of the paintings refer to the archetypal role of woman. Näher has exhibited in group shows from 1980 and solo shows from 1982; principally in Germany, but also in Spain, and America.

Recent one person exhibitions include

1987
Bielefeld, Kunstverein
Leverkusen, Nuseum Schloss Ñorsbroich
Frankfurt, Galerie Grässlin-Ehrhardt
Köln, Galerie Gisela Capitain
Köln, Galerie Janine Mautsch
Madrid, Galerie Juana de Aizpuru

1988
Wolfegg, Alte Pfarr
Frankfurt, Galerie Grässlin-Ehrhardt
Münster, Westfälischer Kunstverein

Literature

The above mentioned shows in Bielefeld, Frankfurt and Münster were accompanied by catalogues.

One consequence of the meeting which perception implies – and for Näher perception usually involves another living presence, actual or implied – is a resulting dilemma between preserving the integrity or isolation of her subjects and imposing her own identity on them.

Against a dark landscape a recumbent nude turns to face two simian creatures loping towards her. Will they continue to advance? Will she repel them? Granted, vulnerability could hardly be depicted in more unequivocal terms. Yet equal weight is given to the woman's power to resist them by meeting them as equals. Only one thing is certain: the confrontation must take place. In her second period Näher included the viewer in the painting. And the viewer was an Everywoman character, a representative viewer incorporated into the composition. Just as animals were never forced into fixed symbolic roles at this stage, so the woman appears as an infinitely flexible figure capable of engagement with or submission to a multitude of external forces. Both the speed and the intensity of the act of painting show that the artist is implicated in every possible way; creation almost verges on some instinctual reaction, an explosion of energy which qualifies the stylistic diligence which preceded it. With the offset figures of animals and women Näher had devised a personal genre in which it was possible to run the gamut of available styles while half consciously working towards her own definition of woman as the sum of pressures she is capable of withstanding. Confrontation is often depicted as a battle in which woman appears as an army in her own right. One painting shows her carrying threatening beasts in both hands, as if by some magic they have shrunk or she has grown into a giant. Animals frequently serve as allies. Yet throughout Näher's work their relationship to people is never distinct; though sometimes that nature seems independent, unfathomable, in general no definite barriers separate humanity from animals. As if to emphasise that point, Näher's studies of cyclops, centaurs and minotaurs explore the consequences of man's animal nature. By deliberately taking images from the common fund of a Western tradition many centuries old, she is able to make the figure of the woman extend over the same historical span. In a statement from 1986 Näher claims to have been alive 10,000 years. The female figure in that second stage of her painting is undoubtedly the artist herself, forging her identity, recording her changing fortunes, sublimating her emotions in a way that would seem diaristic if its locale and detail were less general.

By the end of this period, light has been almost totally extinguished, the naked heroine has been ousted by a band of jeering predators, their teeth glinting in the light of a fire. The withdrawal, and the third phase of the self and other dialectic begins when Näher abdicates her position as one element within the picture. After this we and the artist occupy the same position, of an eye discovering its subject. The viewpoint is almost always further away than in the past, as spectacles far distant in space and time are summoned by means of a technique which advertises the fact that they consist of nothing but paint and canvas. The sense of artifice is unmistakable: matte paint applied in broad planes with little interest in colour but a heightened feeling for dramatic lighting possesses a coherence which has been built up gradually, by collocation of strokes and tones.

But Näher's artistic growth, with its tripartite development, has been subject to other principles. One suite of prints provides some clues as to what they might be. A transitional work, *Das Hexenbilderbuch* (*The Witches' Picture Book*) 1973-75, a collection of nine lithographs on the Walpurgisnacht sequence from Goethe's Faust, foreshadowed the end of Näher's approach to nature as distanced and alien.

Näher adapted Goethe's poetic sequence to make an unfinished visual *Bildungsroman* of her own, replete with choices and temptations which combine moral and emotional decision-making. A surrogate heroine is lodged between planes of reality and otherworldliness, both (perhaps) equally unacceptable in terms of what American psychologists call 'life-decision'. This indicates a desire for compromise which may not be evident in the second period women-animal studies: the desire for an art sufficiently poetic to suggest a wider range of possibilities but sufficiently

in touch with daily life to make it relevant outside an easily dismissed area of fantasy.

What if the signs of madness in Näher's work indicate the hysteria which accompanies a change of direction, the transition from one period of her work to the next? And what if the periods of her work correspond, however roughly, to Michelet's stages of the development of the figure of the witch in history from precise, timid listening to a rampant urge to assume control, then finally to a figure distanced from the tragedies she depicts, reliant on a language in which she has insufficient faith, uncertain of everything except the ceremony of her work and 'the price of an illusion'? Taking her place as an intellectual has been the end of a slow process for Näher, an untheoretical, poetic thinker who admits no motive but pure compulsion. But the secret of the process has been her ability to question her own assumptions. Those dark drawings of 1983 and *Das Hexenbilderbuch* in particular demonstrate a rare ability to provide a subtext or running commentary on her activity. Each stage of her development has been marked by a different phenomenological proposition, an altered relation between self and other. In the latest paintings nature seems far off, resistant to negotiation, visible but unchangeable. No longer in control of her own fate, the artist/witch/intellectual becomes a visionary, making contact with places and feelings, recording intuitions in an art which questions itself even in the course of its making, a matter of finding, not seeking.

Stuart Morgan

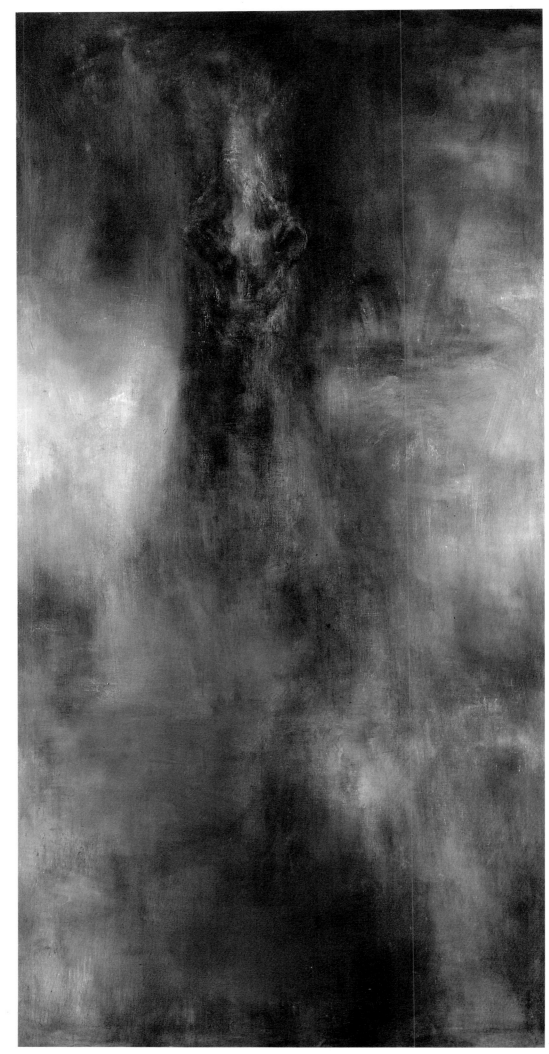

38

CHRISTA NÄHER
Apocalyptic Horses
'Hunger' 1988

CHRISTA NÄHER
Apocalyptic Horses
'War' 1988

BETTINA GRUBER
MARIA VEDDER

Bettina Gruber was born in 1947. She studied at the Academy of Visual Arts, Berlin. Maria Vedder was born in 1948 and studied photography and social sciences, and theatre, film and television. Both have specialised in video, film and photography. Vedder lectured in electronic media at the Univerity of Cologne, and is a founding member of Media Art Production e.V., Zentrum für künstlerische Forschung, Produktion and Präsentation. The two artists have worked individually and together, making their first collaborative work in 1978. Since then they have made around ten tape and installation works. They have exhibited widely together since 1978 in Europe, and further afield. Their work has entered the Museum Ludwig collection, and has appeared on television and in magazines. They have also collaborated on two publications.

They have recently participated in exhibitions at:

1988
Köln, Museum Ludwig
Valencia, 1 Mostra Internacional De Realitzadores de Videocreacio
Köln, Kunstverein
Marl, Skulpturenmuseum
Montbeliard, 4e Manifestation Internationale de Video et de Télévision

Literature

Maria Vedder and Bettina Gruber, DuMonts Handbuch der Videopraxis, *Köln, 1982*

A wooden rowboat placed on a high, narrow pedestal. In the boat is the figure of a dog with a long tail and pricked up ears. The figure rows in nonexistent water whose presence is indicated by the pedestal's having been painted blue and then set spinning on its axis. As it turns, one can see that a stylized eye has been painted on one of its edges.

From the very first picture on, a simple, rhythmic music is to be heard providing a background of an unvarying, constant lightness to the whole tape, a music which appears to be engaged in a dialogue with itself alone and yet manages to give the spectator an acoustic handle on the events.

A title is faded into the picture of the rower in his boat: 'Der Herzschlag des Anubis' (The Heartbeat of Anubis). This fade-in is framed by two intercuts, each tenths of a second long. They show a pan down columns set in gold and blue ornamentation. They provide a kind of setting for the title, putting it apart from the rest of the tape's field.

The subsequent shots first appear as short intercuts, but then become sequences of ever-increasing length. A man, prone, seen from the perspective of his head and thus extremely abridged, is blowing a tooter quite artistically, imparting to what is actually a thing of the highest banality a life of its own. This life manifests itself in the tooter's depicting figures bearing a highly evocative power of association.

The visual narrative slides into showing a group of little clay falcons dwarfed by a wire trestle, upon which a neon yellow half moon has been mounted. The whole group turns around and around incessantly. The camera, which has crept up quite close to it, regards it. Then, suddenly, a live being, a dog sitting quietly in front of the camera. A Super-8 sequence is projected on to his head. It shows a leopard attacking an antelope, killing it the way leopards do: by snapping its neck and waiting for it to die, something that can take as long as 8 minutes. The camera slips away from this picture and returns to the original shot of Anubis rowing in his boat, then to fade out gradually, as one light after the other is turned off. While this 'turn out' is going on, the credits run across the screen.

The film was produced using very simple technical means, then put together by means of uncomplicated and precise cuts. The special colour quality in the video was based on the primary colours of blue and yellow and achieved with lighting alone. This preference for simplicity has been evident in all of the pieces the two Cologne artists have produced since beginning their partnership in 1978. It represents however more than the artists' individual insistence on what has become a characteristic of their work. Rather it is typical of a whole group of artists. Their work does not so much focus on what technologies and theories of communication video can present, but on what it can tell about the characteristics of our perception – our sense of aesthetics. While this preference might have originally been a result of their having inadequate means of production at their disposal, Gruber / Vedder have learned how to make a virtue out of a necessity. They have found a language whose aesthetic and cultural syntax meshes with the production techniques at hand. As the tapes shown since 1984 have indicated, the primary thrust of their work is using the TV screen as the border of an expanse, inside of which pictures are received. This border does not confine their artistic imaginations, does not force them to try to break out of it by either going inwards into the universe of electronic effects or outwards through the use of installations. Rather they see the screen as a given. It is a visual field characterized by a fixed form and a very small variation in size, a field which predicates first and foremost an individual, perhaps even intimate, reception of the images it displays. The structures of aesthetics stipulate that one of the artist's most important objectives is to fashion this expanse, the 'grey sheet' of the TV screen. To do this, he has at his disposal the classic instruments of artistic expression: composition, drawing and configuration of colour. It is precisely this 'painterly' aspect of video which is conveyed with such clarity and sureness of touch in 'Anubis'.

Another aspect of video's sense of aesthetics is the way it is textured. Texture structures a work of art and always poses problems for the artist. Gruber / Vedder have solved it by first structuring the links between the

individual sequences. They use a cutting technique which works against normal arrays of time. Practically this means that opposing pairs of sequences are cut so that both get progressively longer or shorter. Through this balance of length, both of them merge into each other, creating an immobility of nearly architectural proportions, one that stands in direct contrast to the pictures running across the screen. This constructive, static element is stressed from the very outset on (as mentioned above) by the framing of the title by the intercutting to the shots of a column. Through it, the title is imparted something of the fixedness of a painted picture.

This interweaving of sequences also counteracts the moving picture's inherent, latent bent towards narrating a story. The ordering of the sequences does, of course, bring a story into being, one which is de-emphasized in favour of the nonverbal impact of the pictures. The story never gets beyond implying a range of possibilities. It is thanks to this shift in emphasis that the artists are able to accomplish something very rare in video: the moment in which the pictures themselves are the story's vehicle, rather than having the story illustrated by the pictures. In this respect, it is possible to see a similarity to Bill Viola's 'I do not know what it is I am like', despite all of the differences in technical matters and approach to the world as a whole. For Viola also uses montage, dissolves and expansion of real-time shots, but while he does it to conjure up a poetic idiom of the search for our own origins, Gruber / Vedder, on the other hand, strive to get rid of, or at least avoid, all elements of poetry in their works. The means to their ends are two-fold. There is the level of the world as a model, the 'puppet house of images'. And then there is the other level, in which the video screen is a picture and a frame. Common to both levels is the artists' insistence that the pictures running in front of your eyes are artificial and have no claim to be authentic. The fact is that Gruber / Vedder see an ideology lurking behind the striving to display 'authentic' pictures and they distrust it. The individual messages in pictures, they feel, are dependent upon the language-based concepts they impart. This means that the messages are products of the conventions and norms which language presupposes, which it has to presuppose so that human beings can communicate with each other. This does not mean that things we register in words go by the names we have given them. Therefore, the authenticity that language claims for itself and its names, that it will insist on in pictures, is what Gruber and Vedder see as an ideology and which they strive to dispel. That the relationship between the encoded symbol and the truth inherent in the object itself is only a relative one is one of the main subjects of their videos. The little tooter being tooted by the prone man (played by F H Heubach) is first seen in a close-up, evoking associations with birds, ghosts and all sorts of intricate figures. Then the camera zooms to a shot of the whole area and the picture is clarified by the establishment of its 'true' dimensions. This special sense of how to stand spatial and perceptual circumstances on their heads is a characteristic of the aesthetic behind Gruber / Vedder's work. It also produces an original kind of comic effect in the pictures; it makes them quite entertaining. Helping achieve this ability to amuse is the light, simple music, the 'world of the puppet house' and the colour scheme selected. Together they stimulate us and bring us to laughter, opening us up and making it possible for the tape to be taken in on many levels.

But the story the tape relates is not at all funny. Anubis is the ancient, Egyptian god of death, identified here with Charon, the Greeks' ferryman between the land of the living and the spirit realm. The added dimension of being a mythical object is given to the tooter by associating it with a prone man. This spatial arrangement is a short allusion to another ancient Egyptian myth, this time of Isis and Osiris. Her lover has been killed, hacked to pieces, and the pieces strewn across the face of the earth, so Isis laboriously looks for them, gathers them up and puts her lover Osiris back together. Finally she lies on top of him like a 'roosting bird' and thus brings him back to life. Death is also the subject in the sequence with the dog. If one does not wish to accept his presence as being a somewhat heavy-handed allusion to Cerberus, the hound of Hades, who let all of the

souls into the realm of death but not out of it, one can see the importance contained in the fact that an animal is being shown, as the animal is a symbol of life, and life means movement. The projecting of the leopard going about the grisly business of killing on to the head of a tame dog shows that movement can also mean death and thus creates a bizarre incongruity between the contents of the two pictures.

Being told here is a story of death, but not about death. It engenders an aura of melancholy, something which, however, will only be felt by someone who is prepared to let himself get involved with the real subject of the tape by transcending all of the borders imposed by aesthetic formalism and pictorial theoreticity. It is precisely this effort required and this state of affairs which makes 'Der Herzschlag des Anubis' by Bettina Gruber and Maria Vedder such a magnificent work of art.

Friedmann Malsch

The Heartbeat of Anubis
1988

A model of a rowboat used on interior lakes.

or
the Anubis-Charon Tableau
or
the telling light
or
. . .

the tooting man
or
the Isis and Osiris Tableau
or
the air under the wings
or
. . .

pencil sharpener, wire and paper
or
the Horus Tableau
or
the hovering night
or
. . .

Flicki
or
the Cerberus Tableau
or
the black shadow
or
. . .

BG/MV

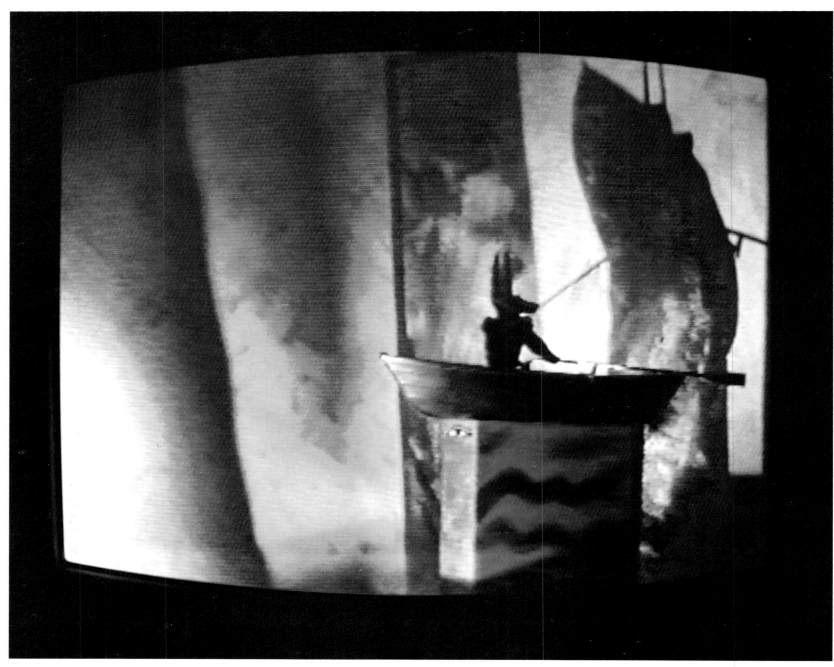

BETTINA GRUBER /
MARIA VEDDER
The Heartbeat of Anubis 1988 (video still)

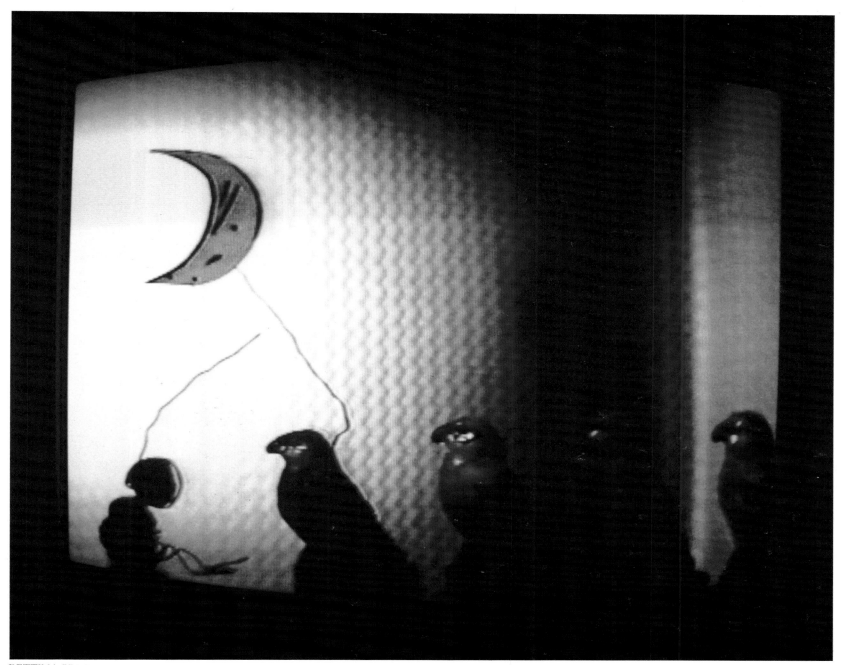

BETTINA GRUBER /
MARIA VEDDER
The Heartbeat of Anubis 1988 (video still)

HUBERT KIECOL

Vom romantischen Anlass
zur eigenständigen Skulptur.
Beton ist neutral und schwer.
Von langer Tradition unbelastet.
HK

From romantic origin
to final enduring sculpture.
Concrete is neutral and solid.
Untouched by long tradition.
HK

*Kiecol was born in Bremen-Blumenthal in 1950 and now lives in Cologne. He
studied at the Hochschule für Bildende Künste in Hamburg. He has exhibited in
Germany since 1982. His sculptures and drawings are concerned with
monumentality, and the use of mass and proportion.*

Recent one person exhibitions include

1986
Rottweil, Forum Kunst
Köln, Galerie Borgmann-Capitain
Frankfurt, Galerie Grässlin-Ehrhardt
Köln, Galerie Max Hetzler

1987
Stuttgart, Galerie Ursula Schurr
Berlin, Reinhard Onnasch Galerie
Köln, Galerie Max Hetzler

1988
Bonn, Städtisches Kunstmuseum

Literature

The last mentioned show was accompanied by a catalogue of monochrome plates.

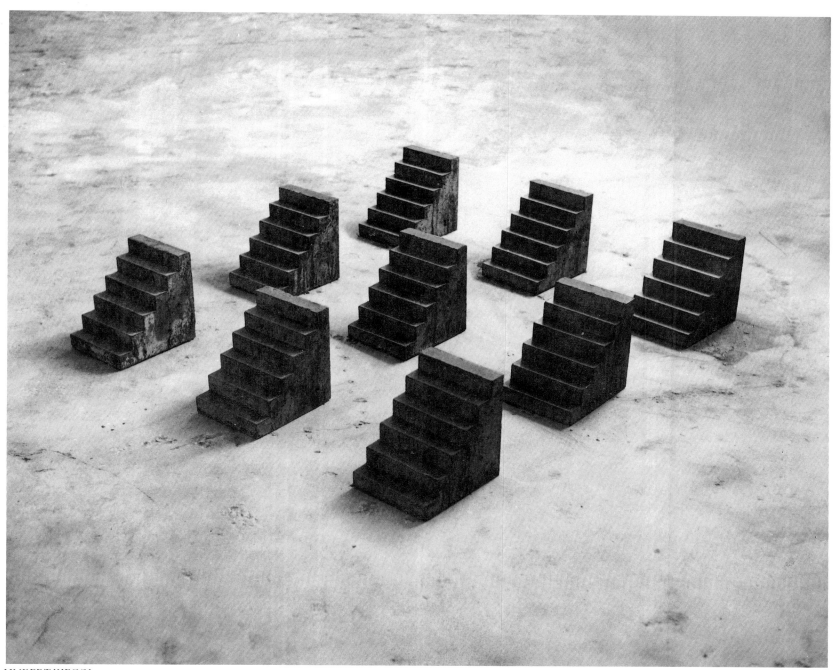

HUBERT KIECOL
Nine Stairs 1989

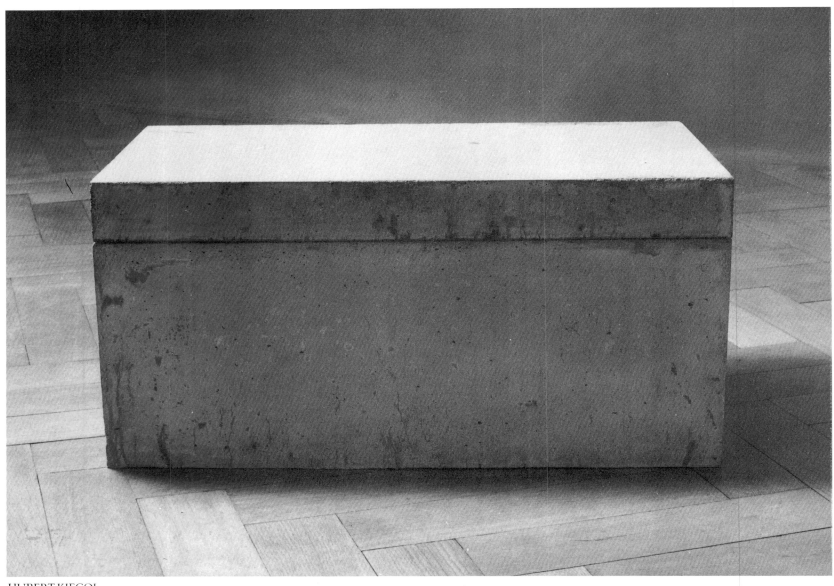

HUBERT KIECOL
All My Knowledge 1987

Opposite
HUBERT KIECOL
Lying Column 1987

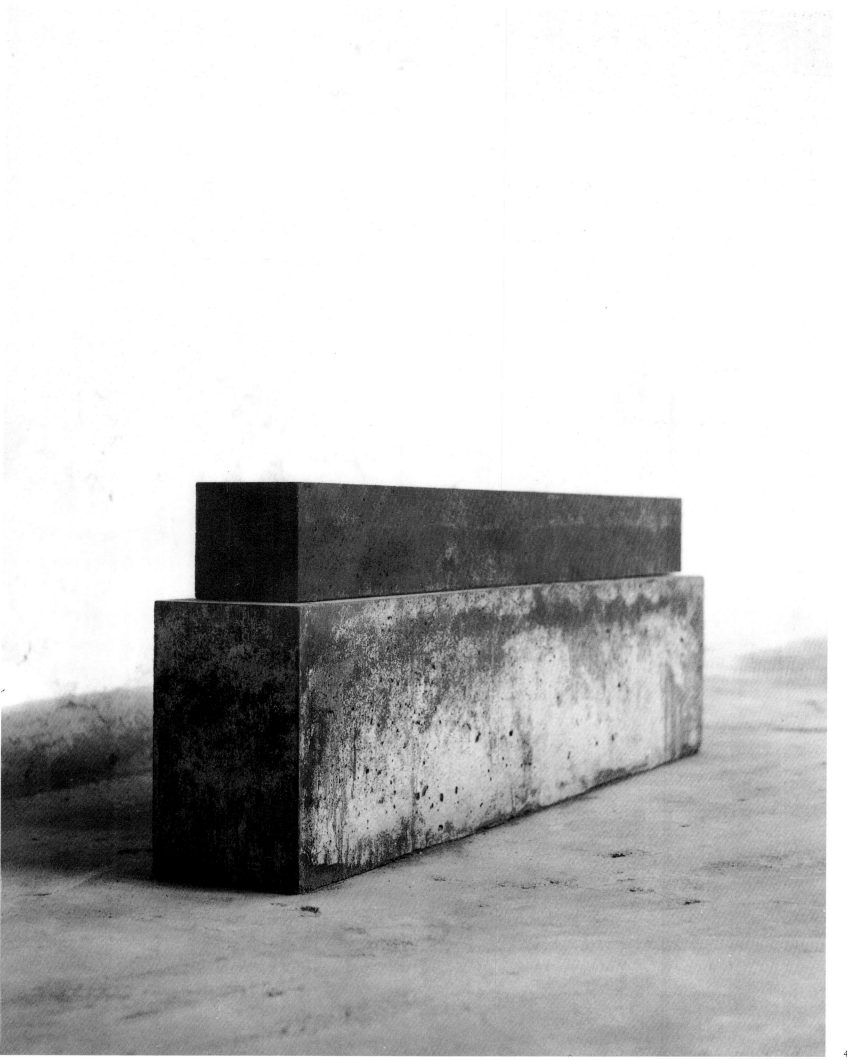

ROSEMARIE TROCKEL

Rosemarie Trockel was born in Schwerte in 1952, studied at the Werkunstschule, Cologne with Professor Schriefers, and continues to live and work in Cologne. She has exhibited widely since 1982. Her studies in anthropology, sociology and theology are reflected in the formal diversity of her work. She explains this diversity as follows: 'I never work by variations; formal development does not appeal to me. Each sculpture is self-contained. I could call it a crude whole, a broad sweep: my sculptures each fill a hole; the hole of the unfamiliar, the unknown; what interests me is discovering the holes'.

Recent one person exhibitions include

1985
Bonn, Rheinisches Landesmuseum
Berlin, Galerie Skulima

1986
Köln, Monika Sprüth Galerie
Bern, Galerie Friedrich

1987
München, Galerie Tanit

1988
Basel, Kunsthalle/London ICA
New York, Museum of Modern Art
Bonn, Galerie Magers (with Walter Dahn)
Basel, Galerie Stampa

Literature

The Bonn exhibition was accompanied by a catalogue, Rosemarie Trockel, Arbeiten 1980-1985, *as was the Basel/ICA show. English language articles include pieces by Jutta Koether in* Flash Art, *April 1986 and in* Artscribe, *March-April 1987, and by Lynne Cooke in* Artscribe, *January-February 1987.*

In the beginning there were drawings, even at this stage offering a broad field for interpretation, in that a large proportion of them had an erotic content, or flirted with this content. As a development from this there came the vase sculptures, produced in plaster and sometimes attaining quite gigantic dimensions (two metres high), a display of wit on the theme of woman as a vessel to be filled, or a mysterious secretive being either closed at the top like an urn, or else designed to be so high that it was impossible to see inside.

The theme of the sculptures was taken up in pictures, though few in number and consciously produced as marginalia, calculated to serve in a supplementary role rather than to play a lead themselves.

The 'perfume pictures,' however, are an exception to this. Some sprayed, others conventionally painted, these are a mannerist parody of different perfume bottles and brands, intended to be seductively slogan-like and representing a step away from 'personal' work into a series of pictures from which personal identity has been deleted.

This is work which hints at the temptation to give way to the seduction of the 'beautiful object,' the urge to consume; and yet at the same time to distance the personal from oneself, to feel guilt and yet to raise one's own innocence as a topic for debate. Transparent work like this was followed or indeed accompanied in parallel, by a new resistance in the form of sculptures: round mosaic surfaces ringed with a finely forged railing, the handrail ending in the head of a snake.

Transparent, ambiguous, multifaceted... the work of Rosemarie Trockel throws into question her actions as an artist, erases what has just been written, however confidently, often collapsing upon itself. Stylization in one direction or another was followed by a renewal of parody: the *Apes* series. Again employing a variety of techniques (drawings, sculpture, spray-painting/drawing), after self-stylization came a turn towards materialism. The human head as ape's head, as king, or this process in reverse order, all played off one against the other. The history of man as viewed from a bench in the zoo or confronted by stuffed animals, or else from the base of a china figurine (the three laughing apes).

At first sight, Rosemarie Trockel's works today are almost always moving; but a longer study shows them to be as dry as bone-dust, porous, and independent (i.e. offering no avenue for a comparison with, for example, Clemente drawings or with a certain aesthetic apparent in the drawings of Beuys, with which her early drawings have often been compared); the best of it is disturbing to one's innate drive towards harmony.

All sense of harmony indeed was disturbed, undermined even, from the beginning of her series of knitted pictures. At her first museum exhibition in Bonn (Rheinisches Landesmuseum, 1985, which coincided with the publication of a representative book about her work) there was a single room with the first small knitted pictures, and then, along with the drawings and the sculpture, a monstrous shelf holding a number of simulated skullcaps, a sculpture as seen in a dream. Here Trockel had allowed herself to yield the myth of the unconscious dream picture to 'automatism,' and to make from it an immensely serious creation, not at all playful now, but sobering and contrasting with the drawings, themselves easily interpretable as erotic fantasies and yet both sculptures and drawings are also commentaries on the 'dream' or the 'erotic.' Commentaries anchored in assertions, in the possession of areas assigned to femininity, and in the checking off of these areas. With Trockel the transition is not offensive, not even expressly stated; it is something quiet rather, sometimes self-contented or even tender to the point of provoking a slight irritation, with a compounded, suppressed and/or distanced passion and a joy in static warfare. And yet an offensive came at last with the knitted pictures. Not only was the argument against women in art ('Women are only good for crochet work and knitting; they have no genius...') stood on its head, putting a finger in the wound as it were; it was fed with symbols designed to renew it, render it visible, insisting that it be discussed. Thus a cliché is made the basis of resistance, although it must at the same time

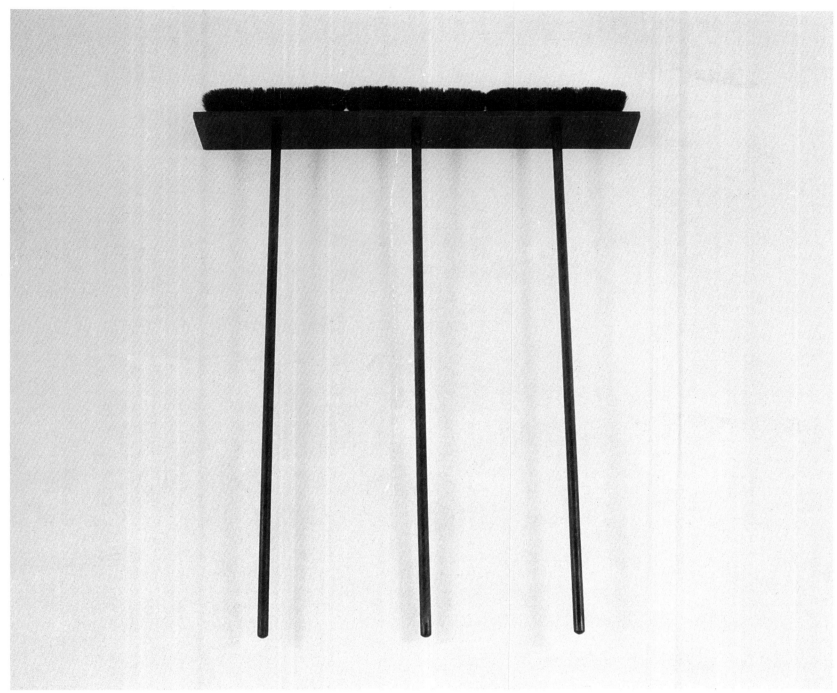

ROSEMARIE TROCKEL
Untitled 1988

continue its nonchalant existence as a cliché. The surface, the texture, the material… the knitting will have it so. The argument is destroyed by the symbols reproduced over and over again in the patterns in these endlessly reproducible (machine-knitted) surfaces.

In this juxtaposition of hammers and sickles, swastikas, conventional pullover patterns and the 'Woolmark' (Pure New Wool), itself a provoking relativization, lies the secret of the creation of a picture without emotion and itself evoking no feelings, a stranger to any brush, hand or flourish. It has a kind of paradoxical functionalism such as no painted work could emulate. The transformation of these knitted pictures into actual articles of clothing was the logical next step. The choice of garment, however, represents a decision to return to art, which is to say to contradictoriness, assertion and resistance.

Jutta Koether

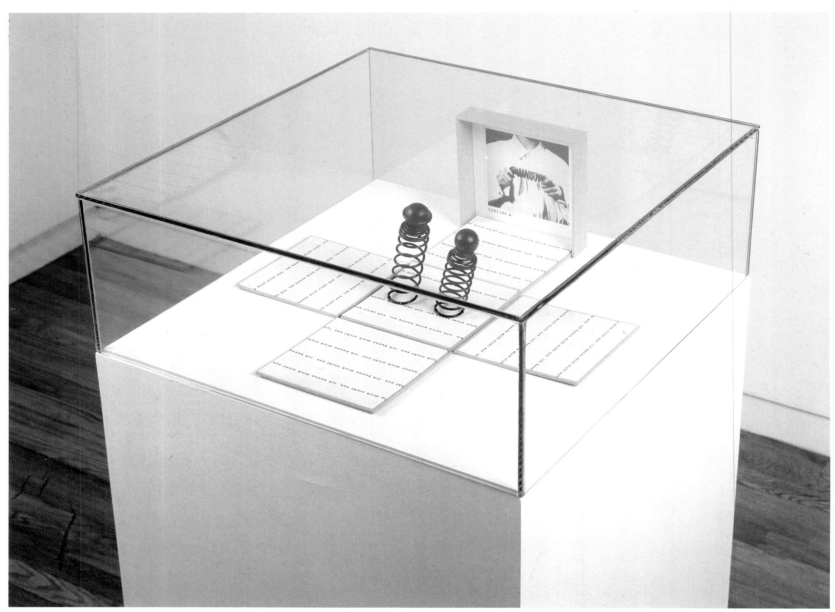

ROSEMARIE TROCKEL
Untitled 1986

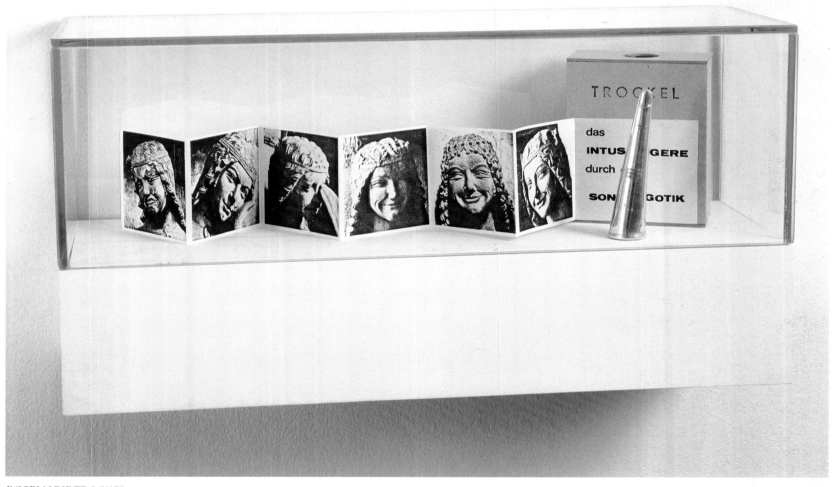

ROSEMARIE TROCKEL
Untitled (Das Intus Legere durch die Sondergotik) 1988

KLAUS vom BRUCH

Klaus vom Bruch was born in Cologne in 1952, and continues to live there. He studied art at the California Institute of the Arts, Valencia between 1975-6, and philosophy at Cologne University until 1979. He made his first videotape in 1975, and has made over twenty tapes and video presentations in Europe and America since then. His work uses repetition, both in sound and image, to create a rhythm that is either hypnotic or obsessive. The tortuous interiorization of the tape contrasts with the global importance of the events featured. He has recently played on the concept of separating tape and monitor, emitter and receiver in large-scale sculptural installations.

His recent video installations include

1986
New York, New Museum, 'New York Azimut'

1986
Köln, Galerie Daniel Buchholz, 'Attack and Defence'

1986
Bonn, Kunstmuseum, 'The Chill of a Mediocre Soul'

1987
Kassel, Documenta 8, 'Coventry-War Requiem'

1988
Winnipeg, Art Gallery, 'Up on the roof top'

1988
Mönchengladbach, Städt Museum Abteiberg, 'Radarraum'

1989
Stockholm, Moderna Museet, 'Kiruna-Project'

Literature

The above exhibitions at Bonn, Kassel, Winnipeg and Mönchengladbach were accompanied by publications

The temptation to identify the metal construction suspended from the ceiling as a mammoth coat hanger has its attraction. Perspective is all, it seems, the more sprightly the speculative dance. No less bizarre is the fantasy that it might be a crescent moon out of the customary diagonal, its horns downward-pointing in space. Reality is other than this – of that there is no question. The obverse, if it has a deeper meaning at all, is a different matter altogether. After the first impression, perception settles on the image of paraboloid rotating constantly about its own axis. A brief glance and the code yields up its secret: a palindrome. Radio Aircraft Detecting And Ranging. Write down the initials, spell them forwards, spell them backwards. Even the most unenlightened tabloid could not fail to get it right. If one focuses purely on the impression, associations with the flight of birds spring to mind. Though anorganic – it's driven by a motor with an output of 20 watts mounted above the intersection – there is still a feeling of beating wings simulating the infinite, the absolute. The space-devouring glide of the wandering albatross, whose wing measurement from tip to torso is virtually identical with the span of the paraboloid. A striking comparison, perhaps, but then again only an image. The directional antenna turning in an anti-clockwise direction is much more than that. Primary radar is the keyword. Electromagnetic waves used to determine the position of variously moving objects. Primary radiation, secondary radiation. Moving targets. The principle is quite simple. Waves of a particular wavelength are cut up via the pulse generator into impulses of a few thousandths or millionths of a second. Radiated into spaces, they are repeated at a rate of several thousand per second. Pulse recurrence frequency is the word. The registering of the target sighting on the cathode ray tube, with a fraction of a millisecond's delay, can follow unimpeded. As the shout, so the echo. But appearances are deceptive. What is known is not necessarily understood just because it is known. The monitors distributed concentrically around the room, and accommodated in three cube-shaped constructions which simulate a mechanical upward movement while actually remaining static, tell a different story. Something is missing from the déjà-vu repertoire: there is no plan position indicator. No electronic beam sweeps across the panorama in search of a suspect target, plotting the same curve over and over again on the circular display panel. Instead, expressionistic colour rasters reminiscent of computer tomographies. Indicated on the screen, though not easy to decipher, are depth of field, temperature, and speed in knots. A pandemic spread of gratuitous nonsense, one might be tempted to think. As Duchamp said: science amusante. Seen from a midway position, neither the one nor the other is right. The model works perfectly from a technical point of view. Using superhigh frequency, radar requires a minimal distance of just under ten metres at a frequency of 3-30 GHz. If we calculate the length of the search radius from its source at the centre of the exhibition area, it is clear that the frequency has to be reduced if the target is to be achieved. Long waves oscillate at a frequency of 30-300 kHz, which puts them in the ultrasonic range. Sound Navigation and Ranging. Impulses emitted via a magnetostrictian vibration generator home in on a sound-reflecting object. The time it takes for a radio wave to travel from a transmitter to a target and back again is stored and the information used to decode the distance from the target. Input and output in computer jargon. To make a graphic comparison, one could say that sonar operates with a warning system similar to that of the family of Rhinolophidae. Through its nostrils, reminiscent of a horn loudspeaker with variable focusing, the bat emits high-frequency sinusoidal oscillations, which enable it to get a strategic bearing on the enemy. The horseshoe bat, with an average oscillatory capacity of 80-100 kHz is more or less on the same wavelength as a standard echo sounder of 50-200 kHz. Taking into consideration the speed at which an ultrasonic wave is transmitted through the air, this corresponds to a range that starts at a few centimetres and extends to a distance of almost a hundred metres. Things have come full circle. Sonar instead of radar. Moving targets. It's like carrying coals to Newcastle, because the brilliant stratagem of making the technically impossible

possible ultimately misses the mark. Simulation in the cross-fire of the verifiable. As Duchamp said: science amusante. The questions remains: where is all this leading? The set-up really does serve the purpose of establishing the position of objects moving at variable speeds. But if that were all, it could claim no merit beyond that of dexterity. Everyone who enters the room is amenable to being an acquired target. But like the directional antenna rotating endlessly on its own axis, no one actually gets anywhere. If the eye simply remains fixed on the monitors, the target pursuit doesn't achieve very much. Invasive as the stealthy virus might be, spotting it doesn't lead anywhere. Reality only possesses truth from the point of view of the absurd. The greater the apparent danger, the greater the certainty that the casual stroller will be infuriated by it. The semblance is what counts, aesthetically speaking. The place has museum quality. But a cultic presence. So said the architect. Acropolis whisper some – benumbing others complain. Skepsis is needed if conservation is not to degenerate into useless ornament. The Sacred as a mere annex would be like a blind man without crutches. In terms of the amplitudization of space, no movement is so subtle as to avoid falling prey to the waves that are sent out. The colour rasters moving across the monitor screen signalize perfection. But there is an enemy to be sought. If we think about it, this can only be the person who happens to be looking around the room. Platitudinously, one could say that trust is fine but making sure is better. On a metaphorical level, on the other hand, the whole thing can be taken as a challenge. To walk around and inspect the room without succumbing to the danger of falling victim to habit. The grail and fetish both demand transparency. Fastidiousness, at its most relaxed, is not its affair. Language, like every wave produced by an electrical impulse, works with oscillations. The mechanical vibrations which the human ear perceives as sound cover an auditory range of 16 – 20000 Hz. A receiver system, in other words, whose range, comparably speaking, is far below the frequency range of an echo sounder. Target acquisition, on a communicative level at least, does not take place. So is physics know-how a medium of symbolic infiltration? As Duchamp said: science amusante. Each wave has a length appropriate to the reference system in which it moves. Every transmitter transmits on a different frequency. So much for the rather meaningless phrase about being on the same wavelength. With which in mind – talk softly please.

David Niepel

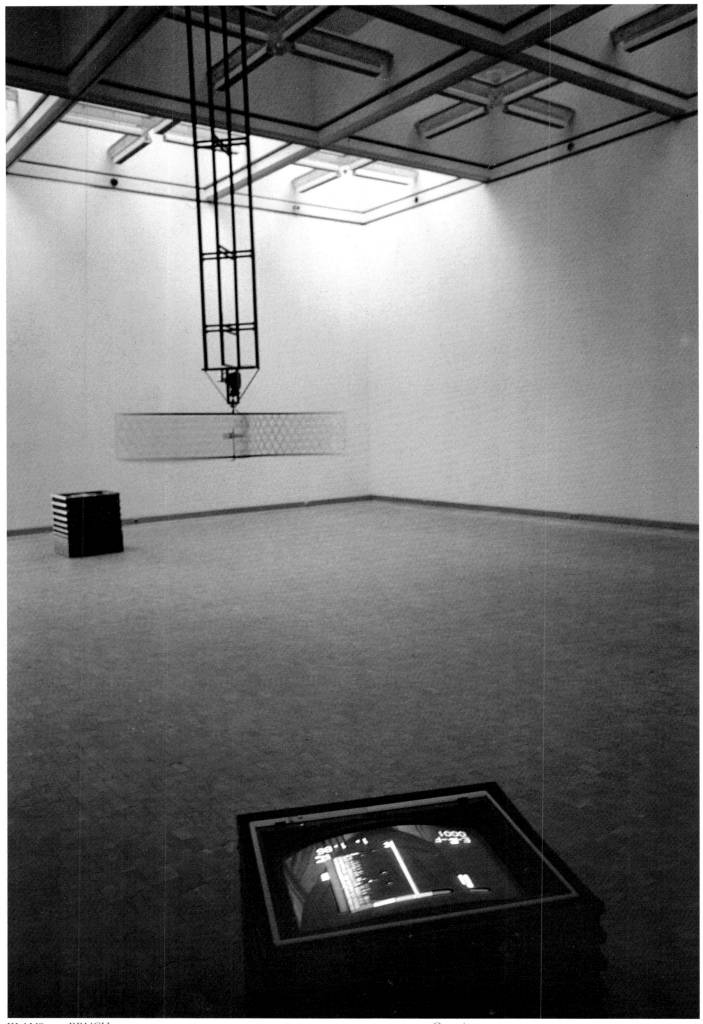

KLAUS vom BRUCH
Radar Room 1988

Opposite
KLAUS vom BRUCH
Attack and Defence 1986

MARCEL ODENBACH

Once Odenbach's tapes went beyond the realm of performance art, of the political and critical debates of the 1970s, of the first affirmative movements toward the medium, his main concern became how to divide space: to see, more and less, in a different way – be it the witness, author, narrator, character, protagonist, presence, silhouette (and it is as much one as the other), or the spectator *en abyme*. In the transactional work *Der Widerspruch der Erinnerungen* (*The contradiction of memories*) 1982, the division of space, remarkably enough, is born in the very first shots out of the continuum of the image itself, marking bodies, matter, lines and lighting. An inner motif of representation exists, or pre-exists, that will become the dividing strip, receptacle of other images. Note how it forms between the protagonist's legs – how, when he goes away, the form is immediately replaced by the lines that appear along the stair and under the door. Note too how, more abstractly, the strip carries the author's signature. And how without becoming an *image*, it is used to code and modify the frame to ensure the transition from one shot to the next –and not just *any* shot: seen from behind, facing a screenlike window, somewhere, someone is having a vision. Transition and coexistence, appearance and disappearance – all to avoid the traditional superimposition of cinema as a mere keying on video.

What is the result of the specific arrangement of the strip form? It would certainly be of little interest without the live, musical quality of Odenbach's work, without his keen sense of the relationship between sound and meaning, of counterpoint and rhythm, and without his highly personal way of getting involved in subject matter to produce not only 'present-day chronicles' but also 'untimely meditations' (exemplified in the German essay tradition by Nietzsche and Robert Musil, but cast in a new lighter form in Odenbach). Obviously the strip lends material expression to the gaze as function: its scansions, its off-field spaces, its excesses, its lacks. Proceeding by variations, it forms and formulates the same, unceasing question: How far can one go in showing less to see more? How much of the visible can be anticipated, guessed, extrapolated, concealed, so that its *share* of absence can be reconstructed from the fragments of its presence? Its active, multifaceted, mobile, virtual, infinite presence: *beneath* and *within* the image, there is already, always, *an* image –are *some* images. Any image is both form and content for another image, born in a limitless background of images.

Circulation, crystallization. Odenbach's art evolves out of his very personal way of being placed between uncertain chance and absolute planning. Through precise elaboration *around* and *out of* the strip form, he has created a peculiar and, in a way, very classical world in which everything seems to answer to and for everything else, and every detail lends to mirror the whole. Elements are deployed in relation to each other, as in a musical score, but they produce meaning, thus causing constant symbolic refractions. For example, the runner's panting, heard during the first half of the installation's first tape, is answered throughout the ending of the second tape by a similar panting, issuing this time from scenes of sex and violence whose sound invades the image. This meaning-saturated world, however, grappling with multiple levels of reality, is also without real exteriority; it does not seem to validate or justify itself in any way. It is drifting, expressing the point of view of a sensibility tested and restored to itself through a form. It is an ever-retreating witness to a world that is suffused in it.

'I believe less and less that I will ever again come to concern myself with the finiteness of the acts and decisions that are within me. Facts have become alien to me. I live more and more in a world of moods.' Odenbach comments. [1] And these words from the 'witness': 'I am left with nothing but emotions.' This world is a place to traverse, and Odenbach's work is a series of such traversals. It has its themes, its constants: childhood and games, a fondness for tinkering and for objects: a fascination with culture, both learned and popular: the German soul with its pomp and circumstance, horrors and myths: Nazism: terrorism: all sorts of music and architecture: a strong culture of the image, cinema (mostly from the US,

Marcel Odenbach was born in 1953 and now lives in Cologne. Between 1974 and 1979 he studied architecture and art history. Since 1978 he has won a number of bursaries and prizes in Germany, and latterly, elsewhere in Europe. His first one man show was in 1976, and he has exhibited regularly in Europe since then. In 1983 he had several shows in Brazil and North America. His art historical and architectural education appears to have been important to Odenbach, whose work betrays an architectural rhythm echoed in his use of classical music. Cinema has also been influential, notably the films of Alfred Hitchcock – whom Odenbach admits to adulating – and Wim Wenders, from whom Odenbach picks up the resonance of displacement and travel through an unreal world. Odenbach's division of the screen, or use of two screens, and suspension of rhythm and music emphasizes this outside or other world.

Recent one person exhibitions include

1987
Paris, Centre Georges Pompidou
Hamburg, Galerie Ascan Crone
Basel, Galerie Stampa

1988
Montreal, Musée d'Art Contemporain
Karlsruhe, Badischer Kunstverein

Recent group shows

1987
Geneva, Centre Genevois de gravure contemporaine, 2e Semaine internationale de Video
Kassel, Museum Fridericanum, Documenta 8

Literature

The above 1987 shows were accompanied by catalogues, as was the Karlsruhe show of 1988.

MARCEL ODENBACH
From the shooting of
In the Peripheral Vision of the Witness 1986

MARCEL ODENBACH
The Distance between Me and My Losses 1983
(video still)

Hitchcock, etc): television (as purveyor of all images): painting (Goya above all): a disturbing attraction (somewhere between perversion and pornography) toward fragmented and dislocated bodies (there are lots of porn flicks in the strip form and/or background): a fondness for African or South American exoticism (quite pronounced in the choice of music): an acute sense of daily life gestures and postures: a pendulum swing between past and present, *imaginary*[2] and reality, matter and memory. All of this feeds back, more or less, into every work, without really dictating a subject matter, or turning into a narration: nor does it ever become a mere pretext for pristine formal operations, or exhaust itself in an excessive (albeit acute) attention to the process of creation itself. What, for example, is this installation dealing with, if not many of these things at once, things that 'congeal' through the strong cohesiveness of the formal apparatus selected to put them together? Is it dealing with the past and present? Obviously. With the point of view that may become the spectator's? Of course. With architecture? Yes indeed. With the body? That too.

If we must finally find one word to describe what Odenbach makes, let's use 'self-portrait' – as it has been redefined by a certain *auteur* cinema, and as today's video permits in a clearer, more natural way.

Many video artists (for example Bill Viola, or Odenbach) have claimed they used themselves as figures or performers in their tapes because it was easier, and that this way they could keep the feeling of intimacy necessary to their experiments. But are we actually – beyond this practical alibi – dealing with a triumph of 'the aesthetics of narcissism?'[3] Undoubtedly. But more profoundly, this is the way a complex expressive mode strives to find itself (to lose and find itself again) in the world of images and sounds. Someday we will have to draw the map and reconstruct the history of the video self-portrait, pinpointing its similarities to and differences from the self-portrait in literature (or painting). For example, in the video works of Jean-André Fieschi or Thierry Kuntzel, Juan Downey, or Viola – and of Odenbach, who seems to come closer than any of the others to the notion of the self-portrait.

Raymond Bellour

NOTES

1 Marcel Odenbach, *Tip, tip, tip, what is this man supposed to be?* (Stuttgart: Walter Phillips Gallery, 1983), p. 34

2 The French *imaginaire*, as used by numerous philosophers, semioticians, psychoanalysts, and film theoreticians from Sartre to Lacan, differs from the word *imagination*, which has a more general use. It designates a special instance – or 'order' – in the human psyche, a realm of fantasmatic projections to be distinguished from reality. The only way to translate this concept is to extend the meaning of the English word 'the imaginary' (which usually denotes 'the fantastic') – Trans

3 Rosalind Krauss, ' Video: The Aesthetics of Narcissism', *October 1* (Spring 1976): pp 51-64; reprinted in John Hanhardt, ed, *Video Culture: A Critical Investigation* (Rochester: Visual Studies Workshop, 1986), pp. 179-181

MARCEL ODENBACH
In the Peripheral Vision of the Witness 1986
(video still)

MARCEL ODENBACH
In the Peripheral Vision of the Witness 1986
(video still)

WALTER DAHN

Walter Dahn was born in St Tonis near Krefeld in 1954. He studied at the Kunstakademie in Düsseldorf between 1971 and 1977, was a pupil in Joseph Beuys's master class, and spent a postgraduate period in New York. His background has been conceptual art. He now lives and works in Cologne. He has participated in group exhibitions from 1976, and in solo shows from 1982, exhibiting in Germany, Holland, France, America and Belgium. From 1979 he was one of the group of six artists who became known as the 'Mülheimer Freiheit Group' from the address of their studio in Cologne. Before he began to paint, Dahn experimented with a variety of means of reproduction, such as photography, polaroids, photocopy, film and video. He maintains an interest in these means, primarily concerned with 'what a picture wants to tell', and playing with the content carried by the medium.

Recent one person exhibitons

1985
Bonn, Rheinische Landesmuseum, 'Fotografien 1983-1985'

1986
Basel, Kunsthalle, 'Paintings (1981-5)'

1987
Eindhoven, Stedelijk van Abbemuseum, 'Paintings, Sculptures and Drawings'

1988
Köln, Galerie Paul Maenz

1988
Hamburg, PPS Galerie F C Gundlach, 'Fotoarbeiten 1973-87'

Literature

Wilfried Dickhoff (ed), Walter Dahn, Irrationalismus & Moderne Medizin, Works, 1984-88, *Köln, 1988*

The problem of pictorial creation in Dahn's work, and so also his inquiry into the elements of the picture, their relations to one another and to historical or contemporary solutions, developed out of his new state of consciousness after a crisis of creativity which arose in 1983 and which led to a radical change in his conception of pictorial form. The crisis weighed all the heavier and required for its productive mastery all the more reflection, character and ability because Dahn, since his brilliantly carefree years on the periphery of the 'Mülheimer Freiheit', had shown himself to be a painter with an inspired artistic hand at his disposal. This remained consistently apparent through all the powers of association and their aggressive or ironic, melancholic or narrative products, although the message of the picture's content stood at that time in the centre of his activity.

To examine his understanding of pictorial conception at that time, as well as his reaction to concept, seems to be of special interest. The abstract theory of the 70s was evidently interpreted by Dahn and his generation as a content-related instrument, or painting in opposition to and in renunciation of the radically philosophical American-European challenge of conceptual art. Moreover, Joseph Beuys' understanding regarding the conceptual, or in other words the surplus, romantic, consciousness-arousing or -changing capabilities of art was critical for Dahn. His early encounter with Beuys at the Academy in Düsseldorf indissolubly integrated Dahn's pictorial conception with the correlation of image, message, world and artistic ego. The artist remained part of this context as did his work.

It was precisely in 1983 that the affinity to Beuys was effectively renewed, especially as Dahn now acquired his new pictorial conception of composition – in which he had recourse to particular early drawings, which themselves were nourished by the source of Dahn's individual means of invention. The inquiry into superfluity – surplus – which he was able to utilise through those inventions in the pictorial realm, was in the following cycle of pictures narrowed down and sharpened. The 'surreality' of the surprise from the 'Mülheimer Freiheit' years was replaced thereafter by a reflection of the relationship between pictorial signs and ground, which step by step clarified itself and ultimately entirely effaced the trace of the painter's hand.

Once Dahn had decisively, and with the help of the 'Spray Paintings' of 1984 ('Baselitz-Pop', 'Beuys-Soul', etc,) made the division between painting and drawing – that which had been suggested by the thinning of the paint itself in previous sign-like paintings such as 'Selbstporträt mit zeitgenössischen Skulpturen' – further thought led to the Graphic Series, drawing its pictorial world of possibilities, similar to those works by Polke, from the interdependence between drawing and coloured ground. Here also, the new or available drawings were transformed and enlarged into a picture format. The wit and irony in the daring balance of the picture elements were naturally of importance during those months of the year 1985. Dahn incorporated themes of self-portrayal in the iconography of this work; articulated unarticulated questions about the position of the artist as an isolated, laughing, laughed at, portraying or endangered man. Once again, as in the earlier works, an existential sounding and questioning hid itself behind a seemingly light presentation.

He consolidated his sense of pictorial form in the year 1985 in works similar to the former series from 1984 – of which 'Selbstporträt als chinesischer Afrikaner' is representative. This time the painting 'Copyrightman' stands at the beginning. While the narrative impulse is once again restrained, so his painterly repertoire is recovered. The figure stands like Job presenting his wounds and abscesses, with raised arms before the viewer. A pictorial idea of great impressiveness, accentuated through the pompous and yet melancholy ring of black and red, explicitly exhibits both refinement and masterful artistic technique. The inconspicuous distortions of the limbs and the spatial play of the copyright-sign betray throughout a continuously subtle handling of the tension between figure and ground.

This painting can stand as an example of the fundamental principle of Dahn's pictorial conception. The surface of the picture contains varying aggregate states of lines and colours, which refer to a self-expanding, contracting or turning movement of pictorial space. The inner dynamic of the picture is more sensuously perceived than analytically clarified, with fluid zones of transition. A 'surreality' of surprising inspiration has transformed itself into an incoherent space including associations, and in a certain sense remains spontaneous. The conceptual or content-based reason for a picture demands this spatial treatment which, moreover, from series to series effects a dynamic of 'stable' and 'fluid'. This change of method reflects inspiration's course, but also the reaction of the artist to the period and his life.

In this sense, the renewed dissolution of the compact composition of 'Copyrightman' and comparable paintings from the year 1986 appears logical. In the new cycle, Dahn sets up the drawing, as such, in an emphatically graphic way, but uses figurations which point to a symbolical tightening and condensation, as in the works 'Speed of Life' or 'The Jewellers'. The change presented here suggests a general, overlapping definition of the notion of content, and breaks through in the white ground of 1986/7. On the one side, the character of the symbols employed is yet more clearly keyed to the lapidary quality of the new style, while on the other hand, the spatial problem is once again intensified and made more precise. 'Electric Chair' illustrates what is intended. The white ground, as everything and nothing, has *a priori* absolutely no spatial capacity. But the drawing is this time quite symbolically and sparingly used, and the antagonistic colours black and red produce those transitory zones, which even here are not spatially luxuriously realized, but rather occur more often in the conceptual realm, the world of associations, and the reflection of the viewer. Dahn pursues in his drawings the way to the 'found' material – to the graphic 'ready made' – that he employs as the building blocks for his works.

The pictorial logic of Dahn is shown by his avoidance, like Warhol's, of the hand of the artist in the technique of producing silkscreens on canvas. 'Hair' from the year 1987 is an example of this new pictorial structure. A horizontal 2-part canvas juxtaposes anonymous drawings of hairstyles from a lexicon with a photograph of aboriginals. Similar confrontations between photographically developed and graphically produced elements, in a series from 1987, show how Dahn pursued the problems of figure and ground, invention and form etc, so as to provoke an inner-pictorial leap of thought. His pictures are not allegory and yet they employ allegorical method not in order to posit a source of comparison, but rather to enable a quantum leap from appearance to appearance. The problem of transition from one artistic means to another appears once again under the guise of transgression.

Having arrived at this point, the pictorial development of Walter Dahn's work can be understood as a logical series of steps following from his artistic formation, which consequently derives from the level of his current state of consciousness. The pictures simultaneously fashion for the viewer both established facts and symptoms. As Dahn assigns to a picture a position of permanent flow between the self and history, he makes himself into an instrument for the perception of relationships which are made visible precisely through his works.

Magic religious impulses lay concealed in the deepest levels of Dahn's pictorial conception.

Siegfried Gohr

WALTER DAHN
Untitled, from *The Open Block for an Open*
Person in England

ELVIS AND ME

WALTER DAHN
Untitled, from *The Open Block for an Open
Person in England*

WALTER DAHN
Untitled, from *The Open Block for an Open
Person in England*

THOMAS LOCHER

Thomas Locher was born in Munderkingen in 1956, and studied at the Stuttgart Academy of Arts. He lives and works in Cologne. He has taken part in a number of group exhibitions in Germany, and in Venice, Rotterdam, Derry and London. Locher may be seen as a conceptual artist, working with words, letters and numbers, sections or components, ordering or disposing them to betray the mysterious functioning of categorical and language systems.

Recent one person exhibitions include

1987
München, Galerie Christoph Dürr

1987
Köln, Galerie Tanja Grunert
London, Interim Art and Karsten Schubert

1988
New York, Jay Gorney Modern Art (with Thomas Grünfeld)

Literature

Thomas Locher Das Eine Das Selbe Das Gleiche (The One The Same The Identical), *München, 1987*

Not long ago Thomas Locher was invited to take part in a photography exhibition. Not ever having been a photographer, he surprised even himself by participating. A bigger surprise was the photograph he submitted. With simple elements made of cardboard, illuminated in colours as lurid as those of a 1950s Hollywood B-movie he made an abstracted mock-up of the plan of the laboratory in which the atom was split. At first it seems irrelevant to his other concerns. But perhaps it serves as a commentary on them, after all.

Part of a Cologne-based reappraisal of classic American conceptualism, Locher's work recalls both the spirit and the focus of Douglas Huebler's crowd studies, Robert Barry's inert gases released into the atmosphere, Lawrence Weiner's public announcements or Joseph Kosuth's first ontological demonstrations. They take the form of lucid proclamations: light boxes bearing messages, books, paintings on (or rather, behind) glass. In one way the work is simplicity itself. Locher's method is to use the chop logic we use every day. His material is the entire universe as we perceive it. And he, the artist, uses the one to deal with the other as precisely as his means permit, making his own decisions, adjusting those of others, then watching to see what happens. And what happens can be very strange indeed.

'Dog. Amazon. Dilemma. Spoon. Cement. Banana. Future. Discus. Electricity. Groove. Urn. Jubilation. Anvil'. Translation proves difficult; the nouns he chooses all sound a little off-key. And since each is singular, in the sense of not being a compound word, they assume the role of particles.

'Anode. Compulsion. Nozzle. Cedar. Glacier. Marriage. Filling.' Their slight oddness ensures that they will be regarded not as things but as words *for* things, in an order so wild that it becomes natural to invent a tidier one as the reading process occurs: 'Basalt. Tender. Orient. Plankton. Grill. Diver. Guidance. Boomerang. Altar. Wool. Jam. Poverty. Sausage. Jewels.'

If words form constellations, apparently of their own volition – wool/jam/poverty/sausage/jewels – then that process must result from an inner need to organize information that comes to hand. For Locher, that gesture dates back to his childhood, when, as an avid model-railway fan, he collected pieces from complete sets, arranging them differently with each new part he was given. The mental disposition of component parts and their constant reshuffling is the way perception verges on knowledge. 'The World', as the list of nouns is called, suggests that what we register is a tangle of self-created Symbolist poems, each so tenuously related to the next that, the moment comprehension seems imminent, it dissolves altogether. In *Zen and the Art of Motorcyle Maintenance* Robert Pirsig described the invisible knife we all employ to make divisions between the complex of components which confronts us. The process of reducing a complex whole into constituent parts, then (perhaps) arranging those parts so as to make some reconstruction of wholeness, is Locher's theme. And it provides him with a running problem: how to do justice to wholeness and fragmentation alike. Sixties precedents hinted at inner taxonomic faculties which differed from one person to another. Lamonte Young composed music on a single note from a siren, so unyielding in volume that listeners' ears would register not one note but different ones, with silences separating them. Incapable of tolerating such strain for too long, the ear automatically created such rests in order to avoid damage, and the result was that each of them heard a quite different sound. If cerebration proper can be differentiated from what looks like naked perception, Locher might be thought to deal with the former.

Yet his project, which is bound to fall foul of the forces which block either cerebration or raw perception, is so involved with those barriers that every line he draws around something, every word or title he uses, represents some heroic capitulation to enemy powers. Received knowledge forms the basis of works in which (for example) the headings and sub-headings of a thesaurus are grouped diagrammatically in order to demonstrate that they mean to embrace all human experience. In one sense such works pay homage to the concept of wholeness, of grand theory;

EVERYBODY	NOBODY
WHO	WHO
EVERYWHERE	NOWHERE
WHERE	WHERE
FOREVER	NEVER
WHEN	WHEN
EVERYTHING	NOTHING
WHAT	WHAT
LIKE THIS	LIKE THAT
HOW	HOW

THOMAS LOCHER
Everybody and Nobody 1989

Locher reveres thinkers such as Humboldt or Alfred North Whitehead, who straddled science and art. In another sense they expose the fragility of such attempts to be complete, alerting viewers to the semi-fictional nature of the task in question but, more urgently, of the unreliability of available materials. Trapped in a web of words, philosophizing comes to a halt.

But if an urge for clarity underlies Locher's art, so, in equal measure, does the need to avoid nitpicking. Any time we choose, we can start again, defining the world anew. As lyrical and fluid as the thesaurus experiments are daunting, his number paintings adhere to no set pattern, but match number, colour and space at will. After making seven of these Locher stopped, having made it clear that they could go on for ever. But he must have been aware that he could make his point in an opposite way, as Flaubert did with his *Dictionary of Received Ideas*, a celebration of the apparent illimitability of poetic language by means of a presentation of the artificial limitations placed on language in everyday life. In his book *The One The Same The Identical* Locher recites what is known, as if by rote, exposing language for what it is. 'I have observed,' the text begins, 'I have seen, I examined, I have looked closely. I have watched, I have not closed my eyes'. Later, 'Nothing escapes me. I recognize everything. It has become clear to me'. Later still, 'I have regarded myself as an exception. I am like no-one else. I am more than everything else. I am the first. I am unique.' And at this point footnotes begin their chant. 'One-off, incomparable, undivided, special, predetermined, liberated, free, single-sexed, alone.' When the text repeats 'I alone,' 'alone' is footnoted. 'Single, divided, unaccompanied, lonely...' the footnote runs. And suddenly, once more, the text is suffused with emotion. If ordering is motivated by a will to power, that has its own particular penalties. 'I have established boundaries,' the speaker states. Yet with each successive footnote, the number of permutations of the text increases alarmingly and the title of the book becomes easier to understand. *The One The Same The Identical* so disturbs the reader's sense of the unitary, the identical or the comparable, each footnote adding permutations of meaning to an already complex text, that it could be regarded as self-detonating. And finally, the text is about power defused, language floating free of its vehicle, to be given its head for good and all.

Gradually it becomes easier to see why Locher made that photograph of the laboratory where the atom was split. No apples dropping on periwigged heads or naked Greeks jumping out of baths... simply a room, an apparatus, with nothing visible at all. The significance of the experiment for Locher's work could hardly be overestimated. Since his practice consists of dividing the world into parts, he is bound to run head-first against a basic assumption of twentieth-century physics, of the world as a continuum, with the observer raised to the god-like level of creator with each new glance. The footnotes in his book may hint at the downfall of the speaker. Yet it conjures up the undifferentiated, unfragmentable whole which the splitting of the atom inaugurated. It is a problem he will touch on more than once in the future.

Stuart Morgan

	YES
	AFFIRMATION
	TO CONFIRM
	POSITIVE JUDGEMENT
	DEFINITE
(AND / AS / OR)	BOTH...AND
MAYBE	TRUE
(NEARLY EVERYBODY)	I
IT MIGHT BE	BEING
POSSIBILITY	PRESENCE
(SIMILAR)	IDENTITY
INNER	IN
ALMOST ALL	ALL
NEARLY EVERYTHING	EVERYTHING

Above
THOMAS LOCHER
Either/Or, More or Less 1989

Opposite below
THOMAS LOCHER
Order and Identity 1987

NO

NEGATION

TO DENY

NEGATIVE JUDGEMENT

INDEFINITE

NEITHER...NOR **NOT (ONLY)...BUT (ALSO)**

UNTRUE **MAYBE NOT**

NOT I **(HARDLY ANYBODY)**

NOTHINGNESS **IT MIGHT NOT BE**

ABSENCE **IMPOSSIBILITY**

DIFFERENCE **(DISSIMILAR)**

OUT **OUTER**

NONE **ALMOST NONE**

NOTHING **NEXT TO NOTHING**

O R D E R
INTENTION
CLASSIFICATION
PREFERENCE
S T R U C T U R E
PROGRAM
S Y S T E M

I D E N T I T Y
IDENTICAL
A N A L O G Y
SIMILAR
I M I T A T I O N
DIFFERENT
A F F I N I T Y

ISBN 1-85437-020-0
Published by order of the Trustees 1989 for
the exhibition 'Art from Köln',
20 May 1989 – 28 August 1989.

Selected by Lewis Biggs
Exhibition Assistant Jemima Pyne
Artists pages collated and edited by
Penelope Curtis

Prepared by Tate Gallery Liverpool,
Albert Dock, Liverpool, L3 4BB,
Publications, Millbank, London,
SW1P 4RG
Designed by Jeremy Greenwood
Colour origination by Magnum Repro,
St Helens
Printed in Great Britain by
Printfine Limited, Liverpool.